ICONS

Encyclopaedia
Anatomica

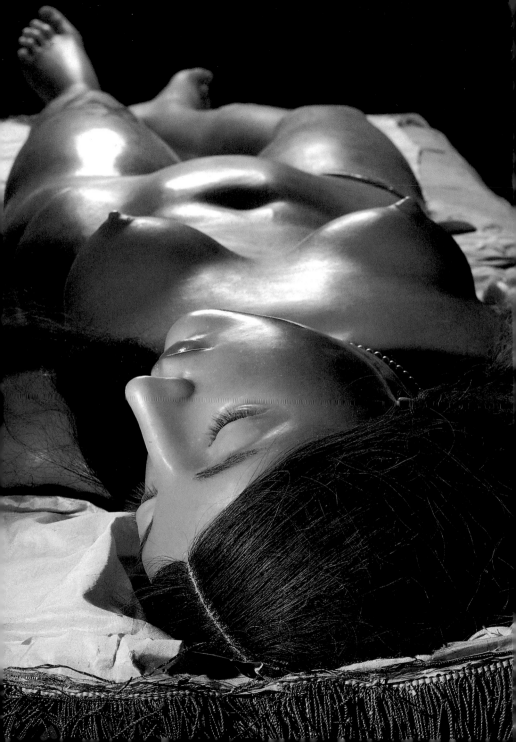

Encyclopaedia Anatomica

A Selection of Anatomical Wax Models
Eine Auswahl anatomischer Wachse
Une sélection des cires anatomiques

With contributions by | Mit Beiträgen von | Textes de
Monika v. Düring, Marta Poggesi

Photographs by | Fotografien von | Photographies de
Saulo Bambi

*Museo di Storia Naturale dell'Università di Firenze,
sezione di zoologia La Specola*

KÖLN LONDON MADRID NEW YORK PARIS TOKYO

Contents
Inhalt
Sommaire

The Wax Figure Collection in 'La Specola' in Florence
Marta Poggesi

The History of the Collection

When Peter Leopold of Habsburg-Lotharingen (1747–1792), Grand Duke of Tuscany (ill. p. 7), decided in 1771 to bring together all the 'scientific' collections from the various galleries in the Grand Duchy, the result was an innovation that was unique not only in Europe but anywhere in the world.

Much earlier than other potentates this enlightened ruler – an enthusiastic student of the natural sciences – had understood the importance of the sciences for the cultural advancement of any society. The first thing he did was to examine the various ways in which the findings of science could be made accessible to all those who were interested.

And indeed the Imperial Regio Museo di Fisica e Storia Naturale (The Imperial-Royal Museum for Physics and Natural History, later widely known as 'La Specola', which means 'observatory' in Italian) was the first of its kind, in that from the day of its opening on 21 February 1775 it admitted the general public to its collections. It is true that there were separate opening hours for the upper and the lower classes: the latter – "provided they were cleanly clothed" – were allowed to visit between 8.00 and 10.00 in the morning, which then left enough time before the "intelligent and well-educated people" were admitted at 1.00 in the afternoon. But however discriminatory this distinction may seem to us today, nevertheless one can still sense how innovative it was to open the museum's doors to this broader public.

These collections had originally been started by the Medici family; immensely important as patrons and connoisseurs of the arts they had also done much to promote the sciences. Ample evidence of this may be seen in the Accademia del Cimento (1657–1667) which had amongst its staff such famous scientists as Redi, Magalotti and Galileo's favourite student, Viviani. After the death of Giangastone, the last descendant of the family, the Grand Duchy of Tuscany went to Francis III of Habsburg-Lotharingen, who decided to have an inventory made of all the treasures in his residence. This task was entrusted to the physician and natural historian Giovanni Targioni-Tozzetti (1712–1783), who completed the work in just under a year in 1763/64.

When Peter Leopold succeeded his father to the throne in 1765 –

after the latter had become Emperor of Austria –
he therefore found that the groundwork for a re-
organisation of the collection had already been done.
The work involved in this major undertaking fell to
Felice Fontana (1730–1805; ill. p. 15), by profession
a teacher of logic at the University of Pisa, but also an
anatomist, physicist, chemist and, above all, an inter-
nationally renowned physiologist. He devoted him-
self to restructuring the buildings with such passion
that by the end of 1771 the first items could already
be moved into the new rooms. As early as 1771 the
Grand Duke had already bought the Palace of the Tor-
rigiani in the via Romana, very close to the Palazzo
Pitti. He had also bought a number of neighbouring
houses and had commissioned the Abbot Felice
Fontana of Rovereto to draw up plans for alterations to these buildings
in order to create a home for his scientific collections. As director of the
new museum, in the early years Fontana travelled throughout Europe
acquiring books and collections and establishing contacts in different
countries. As a result the museum in Florence became one of the most
important museums of its day, not least for its rich scientific library.

Fontana directed the museum until his death. Throughout this
time Giovanni Fabbroni was at his side – at first as his assistant (and
constant antagonist) and from 1784 onwards as the museum's deputy
director, accompanying Fontana on numerous journeys. In 1805 he took
over as Director but only for one year.

It is interesting to note that the money to construct the museum
for physics and natural history (and many other projects instigated by
Peter Leopold) was raised by the sale of valuable objects once owned by
the Medici family – despite a testament left by the Palatinate Electress
Anna Maria Luisa (1688–1743), Giangastone's sister, which decreed
that the estate of the Medici family should in its entirety and irrevocably
remain in the ownership of the city of Florence.

The core holdings of the museum, which came principally from
the Uffizi, consisted of collections (minerals and shells, for instance),
natural history curiosities from the era of the Medici family, Galileo's
instruments and equipment from the Accademia del Cimento as well
as four wax figures by the Sicilian sculptor Giulio Gaetano Zumbo.

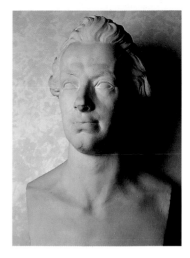

Bust of Peter Leo-
pold of Habsburg-
Lotharingen

Büste von Peter
Leopold von Habs-
burg-Lothringen

Buste de Pierre
Léopold de Habs-
bourg-Lorraine

In 1771 a ceroplastic studio was set up together with other workshops essential to the running of the museum (a carpentry shop, a glaziery and a taxidermy studio): these will be discussed in more detail later in this essay. Keen to have astronomy and meteorology included in the museum as well, in 1780 Peter Leopold commissioned the architect Gaspare Paoletti (who had earlier been involved in the restructuring of the palace) to build the Osservatorio Astronomico (the so-called 'little tower'). This was later to be the source of the name 'Specola', which means observatory. The work turned into a major project which led to the building's being much larger than originally planned. In fact many experts had advised against it and had advocated building on the Acetri hills instead. In 1789, the year of the completion, a part of the Boboli Park was incorporated as the museum's Botanic Garden (ill. p. 8).

After the death of his brother Josef in 1790, Peter Leopold became Emperor of Austria and put Tuscany into the hands of his second son Ferdinand III (1769–1824), who had neither his father's vision nor his skill in matters of government. But the times were also against him: Napoleonic expansionism forced the Lotharingians to give up Tuscany which, after various complications, went to the Bourbons of Parma. During this period the museum started to organise the teaching of

'La Specola' seen from the Boboli Garden; engraving from the late 17th century

Die Specola vom Boboli-Garten aus gesehen; Kupferstich vom Ende des 17. Jahrhunderts

La Specola vue du jardin Boboli ; gravure de la fin du XVIIe siècle

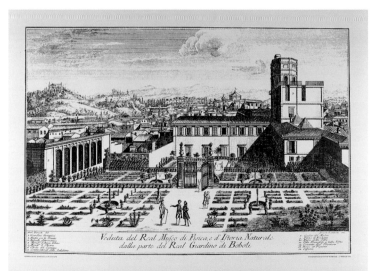

Veduta del Real Museo di Fisica, e d'Istoria Naturale dalla parte del Real Giardino di Boboli

scientific subjects, which was continued in 1814 after the restoration of the Lotharingians.

Under Ferdinand's rule the museum had to survive a period of unrest and lost a great deal of the scientific importance attached to it in its early years when it enjoyed a reputation as one of the most important centres of learning in Europe according to illustrious foreign authors such as Goethe and Bernouilli. Ferdinand also had major structural alterations made to the palace: in 1820, under the direction of the architect Pasquale Poccianti a corridor was constructed joining the Specola with the *Meridiana* wing of the Palazzo Pitti, so that the Poccianti Corridor now extends the Vasari Corridor – which leads from the Palazzo Vecchio via the Uffizi to the Palazzo Pitti – as far as the Specola.

After his death in 1824 Ferdinand was succeeded by his son Leopold II (1797–1870), affectionately nicknamed 'Canapone' by the Florentines on account of his blond hair. It was thanks to him that the teaching and lectures in the sciences were reinstated, with a particular emphasis on the applied sciences relevant to agriculture and the cultivation of reclaimed land. During his time as regent the Tribuna di Galileo was constructed. Dedicated to the memory of one of the greatest scientists, it was inaugurated in 1841 on the occasion of the third congress of Italian scientists in Florence. The Tribuna is a large room on the first floor of the building and was partially rebuilt by the architect Giuseppe Marelli. Work was started in 1830, the initial plan being simply to add an apse to the existing room, but the scheme was then altered in accordance with the wishes of the Grand Duke: in order to lend more weight to his intended celebration of Galileo and his work, the whole room was to be dedicated to the renowned scientist. As well as a statue, it was to contain all the surviving Galileo memorabilia and the instruments from the Accademia del Cimento. The building of the Tribuna, one of the few examples of late Neo-Classicism in Florence, led to a number of important alterations to the palace, most particularly to the floors below the Tribuna. It also meant that a part of the courtyard was roofed over. The room itself was decorated specifically and exclusively with Tuscan marble and with works by artists – sculptors and painters – who were also exclusively from Tuscany.

After the fall of Leopold II – the last Grand Duke of Tuscany – in 1859 the Istituto di Studi Superiori e di Perfezionamento (Institute of Higher Study and Further Education) was founded. In 1923 this became

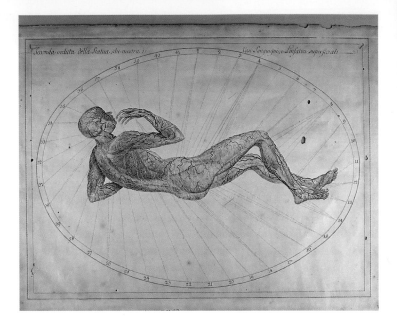

Original drawing of
a recumbent figure,
called *lo spellato*
(Room XXVIII,
display cabinet
no. 740)

Originalzeichnung
einer liegenden
Figur, genannt
lo spellato (Saal
XXVIII, Vitrine
Nr. 740)

Dessin original
d'une figure cou-
chée appelée
lo spellato (salle
XXVIII, vitrine
n° 740)

the University of Florence. The museum buildings became part of the
Institute and now contain the University's Department of Physics and
Natural Sciences.

While the founding of the Institute was of inestimable impor-
tance it also led to the breaking up of the museum into its various dis-
ciplines, which – along with the relevant collections and libraries – had
progressively to be relocated at other sites in view of the constantly
increasing numbers of students. Even the resistance of many scientists
at the time could not hinder this process, with the result that the histor-
ical buildings in the via Romana now only contain the zoological collec-
tions and the bulk of the anatomical ceroplastics.

Drawing of a head:
front view, 2nd half
of the 18th century
(Room XXVIII,
display cabinet
no. 707)

Zeichnung eines
Kopfes: Frontal-
ansicht, 2. Hälfte
des 18. Jahrhun-
derts (Saal XXVIII,
Vitrine Nr. 707)

Dessin d'une
tête vue de face,
2e moitié du XVIIIe
siècle (salle XXVIII,
vitrine n° 707)

Seconda veduta del secondo pajo dei Nervi del Cervello detto Nervo Ottico.

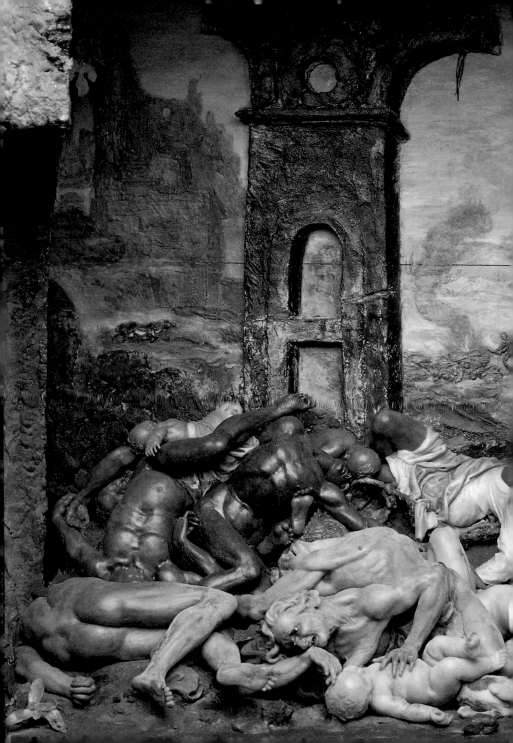

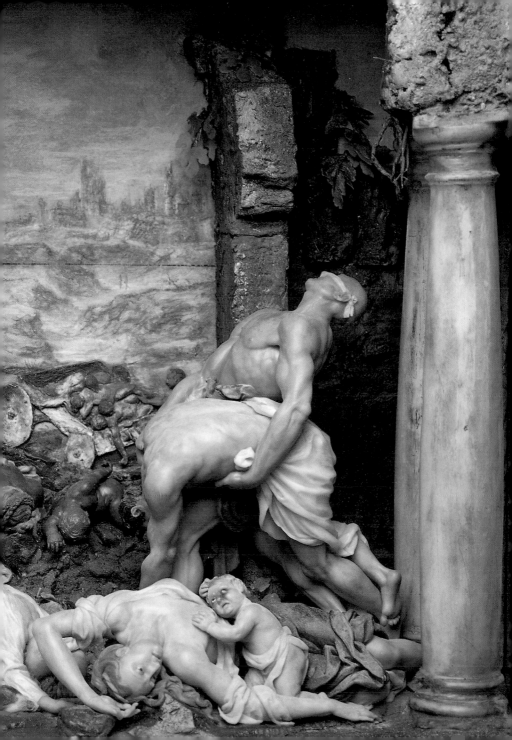

Die Wachsfigurensammlung des Museums La Specola in Florenz
Marta Poggesi

Die Geschichte

Als Peter Leopold von Habsburg-Lothringen (1747–1792), von 1765 bis 1790 Großherzog von Toskana (Abb. S. 7), 1771 beschloß, alle „wissenschaftlichen" Sammlungen der großherzoglichen Galerien in einem Museum zu vereinigen, führte er eine Neuerung ein, die in Europa und in der Welt ihresgleichen suchte. Viel früher als anderen Herrschern war dem aufgeklärten Landesfürsten, selbst ein begeisterter Student der Naturwissenschaften, deren Bedeutung für die kulturelle Entwicklung der Gesellschaft bewußt geworden. Als erster sann er über Möglichkeiten nach, die Errungenschaften der Naturwissenschaften allen Interessierten zugänglich zu machen.

Und in der Tat war das Imperial Regio Museo di Fisica e Storia Naturale (das Kaiserlich-Königliche Museum für Physik und Naturkunde, das später allgemein „La Specola" – „Sternwarte" im Italienischen – genannt wurde) das weltweit erste seiner Art, das von seiner Eröffnung am 21. Februar 1775 an für das allgemeine Publikum freigegeben wurde. Zwar gab es getrennte Besuchszeiten für Gebildete und für das gemeine Volk; letzteres hatte – „reinliche Bekleidung vorausgesetzt" – von acht bis zehn Uhr morgens Zutritt, um genügend Zeit verstreichen zu lassen bis zum Einlaß „der intelligenten und gelehrten Leute [...] um ein Uhr nachmittags". Auch wenn diese Unterscheidung heute diskriminierend erscheint, kann man doch ermessen, wie innovativ die Öffnung der Bestände für die breite Öffentlichkeit damals gewesen sein muß.

Die Einrichtung der Sammlungen ging auf die Medicis zurück, die sich auch um die Förderung der Wissenschaft verdient gemacht hatten, wie das Beispiel der Accademia del Cimento (1657–1667) zeigt, an der zur Zeit Ferdinando II. de' Medici so bedeutende Wissenschaftler wie Redi, Magalotti und Galileis Lieblingsschüler Viviani lehrten. 1737, nach dem Tod Giangastones, des letzten Abkömmling der Familie, fiel das Großherzogtum Toskana aufgrund der Bestimmungen des Wiener Friedens von 1735 an den späteren Kaiser Franz I. von Habsburg-Lothringen, der eine Aufstellung aller in seiner Residenz enthaltenen Schätze vornehmen ließ. Von 1763 bis 1764 inventarisierte der Arzt und Naturforscher Giovanni Targioni-Tozzetti (1712–1783) die Bestände.

Als Peter Leopold 1765 seinen Vater, der zum Kaiser von Öster-

Pages · Seiten · Pages 12–13:

G. G. Zumbo:
La Peste

The plague

Die Pest

La peste

reich ernannt worden war, als Großherzog der Toska-
na ablöste, fand er eine gute Arbeitsgrundlage zur
Reorganisation der wissenschaftlichen Sammlungen
vor. Diese Aufgabe sollte dem Abt Felice Fontana
(1730–1805) aus Rovereto (Abb. S. 15) zufallen, sei-
nes Zeichens Dozent für Logik an der Universität von
Pisa, aber auch Anatom, Physiker, Chemiker und v. a.
ein international renommierter Physiologe, der sich
der geplanten Neustrukturierung mit solcher Leiden-
schaft widmete, daß bereits Ende 1771 der erste Teil
der Bestände in die neuen Räumlichkeiten verlegt
werden konnte. Bereits 1771 hatte Großherzog Peter
Leopold den Palast der Torrigiani (zuvor im Besitz
der Bini) in der Via Romana in unmittelbarer Nähe

des Palazzo Pitti sowie einige angrenzende Häuser erworben und Fonta-
na mit dem Entwurf des Umbaus der Gebäude beauftragt, um in ihnen
die wissenschaftlichen Sammlungen unterzubringen.

Als Direktor des neuen Museums bereiste Fontana in den ersten
Jahren ganz Europa, um Bücher und Sammlungen zu erwerben und
Kontakte zu Gelehrten in vielen Ländern herzustellen. So wurde das Flo-
rentiner Museum zu einem der bedeutendsten seiner Zeit, zumal es
auch über eine reichhaltige wissenschaftliche Bibliothek verfügte. Fonta-
na leitete das Museum bis zu seinem Tod 1805, wobei ihm Giovanni Fab-
broni erst als Assistent und ab 1784 als Vize-Direktor (und permanenter
Widersacher) zur Seite stand und ihn auf zahlreichen Reisen begleitete.

Das Geld zur Verwirklichung des Museums für Physik und
Naturkunde (und auch vieler anderer Projekte Peter Leopolds) stammte
aus dem Verkauf wertvoller Gegenstände aus dem Besitz der Medici;
und dies trotz des Testaments der palatinischen Kurfürstin Anna Maria
Luisa (1668–1743), der Schwester Giangastones, in dem das Vermögen
der Medici unwiderruflich an die Stadt Florenz gefallen war. Zum Grund-
bestand des Museums, der vornehmlich aus den Uffizien stammte,
gehörten Sammlungen (etwa von Mineralien und Muscheln), natur-
kundliche Kuriositäten aus der Zeit der Medici, die Instrumente Galileis
und die Gerätschaften der Accademia del Cimento sowie vier Wachsfigu-
ren des sizilianischen Bildhauers G. G. Zumbo.

Um den Bestand des Museums um die Gebiete Meteorologie
und Astronomie zu erweitern, beauftragte Peter Leopold 1780 den Archi-

Bust of Felice
Fontana

Büste von Felice
Fontana

Buste de Felice
Fontana

*Pages · Seiten ·
Pages 16–17 :*

G. G. Zumbo:
Specimen of a head
(cf. pp. 134, 135)

Präparat eines
Kopfes (vgl.
S. 134, 135)

Préparation anato-
mique d'une tête
(cf. p. 134, 135)

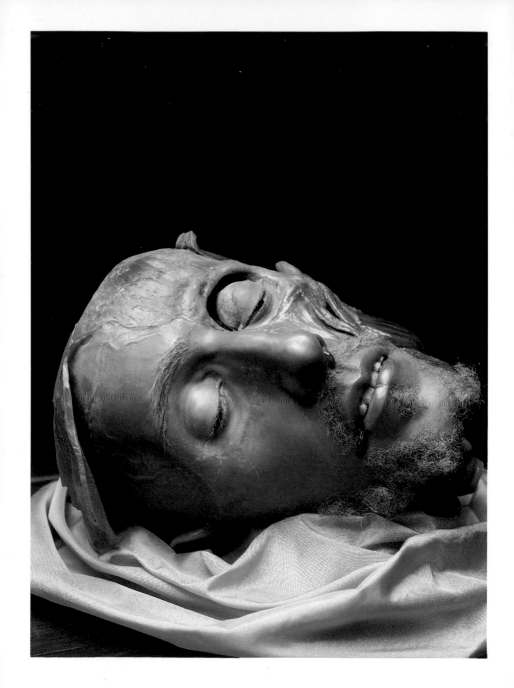

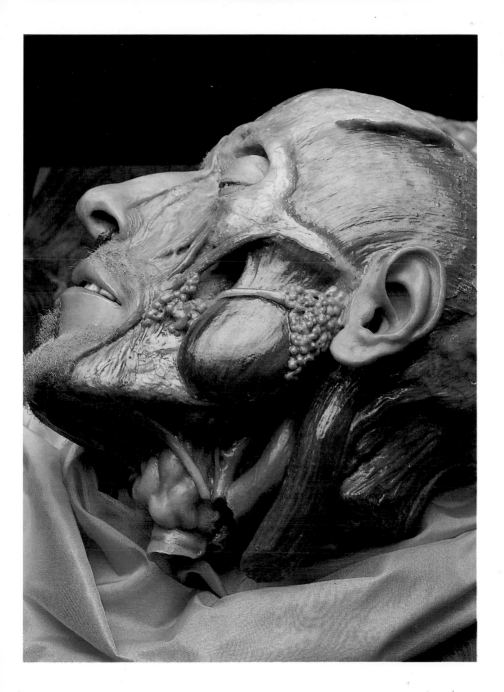

tekten Gaspare Paoletti (der bereits an der Umstrukturierung des Palastes beteiligt gewesen war) mit dem Bau des Osservatorio Astronomico (dem sog. „Türmchen"), der dem ganzen Komplex später den Namen „Specola" (Sternwarte) geben sollte. Das aufwendige Bauvorhaben, das – trotz der abweichenden Meinung vieler Experten, die einen Neubau auf den Hügeln von Acetri befürwortet hatten – zu einer beträchtlichen Erweiterung des Gebäudes führte, wurde 1789 abgeschlossen. In dasselbe Jahr fällt die Verlegung eines Teils des Boboli-Parks in den Botanischen Garten des Museums (Abb. S. 8).

Nach dem Tod seines Bruders Josef wurde Peter Leopold 1790 Kaiser von Österreich und überließ die Toskana seinem Zweitgeborenen Ferdinand III. (1769–1824), dem die Weitsicht seines Vaters ebenso abging wie dessen Geschick bei den Regierungsgeschäften. Erschwerend kam hinzu, daß die napoleonische Expansion die Lothringer zur Aufgabe der Toskana zwang. 1801 fiel die Toskana schließlich als Königreich Etrurien an Bourbon-Parma. Während dieser Periode richtete das Museum Lehrveranstaltungen in wissenschaftlichen Fächern ein, die auch nach der Restauration der Lothringer 1814 fortgeführt wurden.

Unter Ferdinand III. durchlebte das Museum unruhige Zeiten und verlor seinen Ruf als eines der bedeutendsten Zentren europäischen Wissens, was ihm auch von illustren Besuchern aus dem Ausland wie Goethe und Bernouilli attestiert worden war. Auch Ferdinand III. ließ wichtige Umbauten an dem Palast vornehmen: 1820 wurde unter der Leitung des Architekten Pasquale Poccianti der bereits bestehende Vasari-Korridor, der vom Palazzo Vecchio über die Uffizien zum Palazzo Pitti führt, um den Pocciantiani-Korridor bis zur Specola verlängert und so die Specola mit dem Flügel der Meridiana, des Palazzo Pitti, verbunden.

Auf Ferdinand III. folgte 1824 sein Sohn Leopold II. (1797–1870), von den Florentinern seiner blonden Haare wegen wohlwollend „Canapone" genannt. Ihm gebührt das Verdienst, den wissenschaftlichen Studien, insbesondere den anwendungsbezogenen wie etwa der Landwirtschaft, neue Impulse gegeben zu haben. In seine Regentschaft fällt die Realisierung der Tribuna di Galileo, eine Hommage an den großen Forscher, die 1841 anläßlich des dritten Kongresses italienischer Wissenschaftler in Florenz eingeweiht wurde. Bei der Tribuna handelt es sich um einen großen Saal im ersten Stock des Gebäudes, der von dem Architekten Giuseppe Marelli z. T. neu gebaut wurde. Die 1830 begon-

nenen Arbeiten sahen ursprünglich lediglich eine zusätzliche Apsis in einem bereits existierenden Saal vor. Um jedoch dem Vorhaben, dem berühmten Gelehrten ein würdiges Monument zu errichten, größeren Nachdruck zu verleihen, sollte ihm auf Wunsch des Großherzogs der gesamte Saal gewidmet werden und neben einer Statue alle Andenken Galileis sowie die Instrumente aus der Accademia del Cimento beherbergen. Der Bau der Tribuna, eines der seltenen Beispiele des späten Neoklassizismus in Florenz, führte zu bedeutsamen Änderungen der Palastarchitektur; insbesondere wurden die darunterliegenden Stockwerke umgestaltet und ein Teil des Hofes überdacht. Der Saal wurde mit toskanischem Marmor verkleidet, und für die Ausstattung zeichneten ausschließlich Künstler aus der Toskana – Bildhauer, Maler – verantwortlich.

Nach dem Fall Leopolds II., des letzten Großherzogs der Toskana, wurde 1859 das Istituto di Studi Superiori e di Perfezionamento (Institut für höhere Studien und Weiterbildung) gegründet, aus dem 1923 die königliche Universität von Florenz hervorgehen sollte. Die Gebäude des Museums wurden als Institut für Physik und Naturwissenschaften Teil der Universität.

Trotz der Bedeutung der Einrichtung dieses Instituts, markierte es andererseits für das Museum den Beginn seiner Zergliederung in die verschiedenen Disziplinen, die mit der stetig wachsenden Zahl der Studenten mitsamt der dazugehörigen Sammlungen und Bibliotheken ausgelagert werden mußten. Diesen Prozeß konnte selbst der Widerstand vieler Naturwissenschaftler jener Epoche nicht aufhalten, so daß im historischen Gebäude in der Via Romana letztlich nur die zoologischen Sammlungen und der Großteil der anatomischen Zeroplastiken verblieben.

Pages · Seiten ·
Pages 20–21:

G. G. Zumbo:
Il Sepolcro

The burial

Das Begräbnis

L'Enterrement

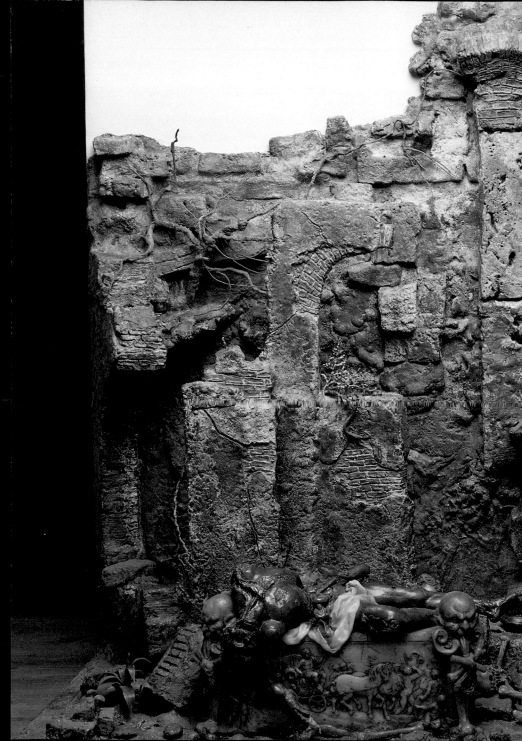

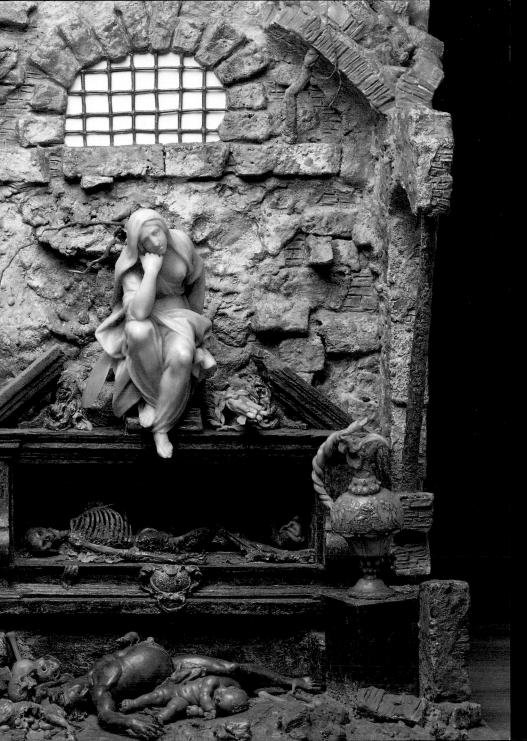

La collection de figures de cire du musée La Specola à Florence
Marta Poggesi

Le musée et son histoire

Lorsqu'en 1771 Pierre Léopold de Habsbourg-Lorraine (1747–1792), grand-duc de Toscane de 1765 à 1790 (ill. p. 7), décida de réunir en un seul musée toutes les collections « scientifiques » des galeries grand-ducales, il entreprenait quelque chose d'absolument inédit en Europe et dans le monde entier. Homme éclairé, bien en avance sur les autres souverains de son époque, le prince était passionné de sciences naturelles, conscient de leur importance pour le développement culturel de la société. C'est lui qui songea le premier à rendre accessibles à tous les découvertes réalisées dans ce domaine.

Appelé plus tard « La Specola », observatoire en italien, le « Imperial Regio Museo di Fisica e Storia Naturale » (Musée impérial royal de physique et d'histoire naturelle) ouvrit ses portes le 21 février 1775, au grand public, ce qui le rendit unique en son genre dans le monde entier. Certes, les heures d'ouverture étaient différentes pour les hommes cultivés et le commun des mortels : ces derniers dont on exigeait une « tenue propre » ne pouvaient visiter le musée que de huit heures à dix heures du matin afin de laisser suffisamment de temps entre leur passage et l'arrivée « des personnes intelligentes et savantes [...] à une heure de l'après-midi ». Mais même si cette distinction nous paraît discriminatoire de nos jours, on peut se figurer que l'accès des collections au grand public représentait jadis une incroyable innovation.

La création de ces collections remontait aux Médicis, grands mécènes et amateurs d'art, qui encouragèrent également les sciences avec la fondation, par exemple, de l'Accademia del Cimento (1657–1667) où enseignaient, à l'époque de Ferdinand II de Médicis, d'illustres savants comme Redi, Magalotti et Viviani, l'élève favori de Galilée. Après la mort de Jean Gaston, le dernier rejeton de la famille en 1737, le grand-duché de Toscane passa, conformément au traité de Vienne, aux mains du futur empereur François Ier de Habsbourg-Lorraine (1745–1765) qui fit dresser la liste des trésors de sa nouvelle résidence. En un peu moins d'un an, de 1763 à 1764, le médecin et naturaliste Giovanni Targioni-Tozzetti (1712–1783) parvint à faire l'inventaire des collections.

Lorsqu'en 1765 Pierre Léopold succéda à son père devenu empereur d'Autriche, il s'aperçut qu'en raison du travail déjà effectué il pou-

vait aisément entreprendre la réorganisation des collections scientifiques. Cette tâche devait revenir à l'abbé Felice Fontana (1730–1805), originaire de Rovereto (ill. p. 15). Professeur de logique à l'université de Pise, il était également anatomiste, physicien, chimiste et surtout physiologiste de réputation internationale. L'abbé se lança dans cette entreprise avec tant d'ardeur qu'à la fin de 1771, on pouvait déjà transporter la première partie des collections dans les nouvelles salles. La même année, le grand-duc Pierre Léopold avait fait l'acquisition du palais des Torrigiani (qui appartenait auparavant à la famille Bini), situé dans la via Romana à deux pas du palais Pitti, ainsi que de quelques maisons avoisinantes. Il chargea ensuite Fontana de transformer les bâtiments afin qu'ils puissent abriter les collections scientifiques. Nommé par ailleurs directeur du nouveau musée, l'abbé sillonna l'Europe durant les premières années pour acheter des livres et des collections et nouer des contacts avec les savants d'autres pays. C'est ainsi que le musée florentin devint l'un des plus importants de son époque d'autant plus qu'il possédait une vaste bibliothèque scientifique.

Egisto Tortori:
Coloured plaster
relief of Clemente
Susini

Gipsbüste von
Clemente Susini,
farbig gefaßt

Buste en plâtre
polychrome de
Clemente Susini

Fontana dirigea le musée jusqu'à sa mort en 1805. Il fut secondé dans son travail par Giovanni Fabbroni qui l'accompagna dans ses nombreux voyages et devint son adversaire permanent en accédant au poste de directeur adjoint en 1784.

L'argent pour la réalisation du Musée de physique et d'histoire naturelle (et de beaucoup d'autres projets de Pierre Léopold) fut obtenu en vendant des objets précieux appartenant aux Médicis et ce, malgré le testament de la princesse palatine Anna Maria Luisa (1668–1743), la sœur de Jean Gaston, qui avait légué d'une façon irrévocable toute la fortune des Médicis à la Ville de Florence.

Les fonds du musée, provenant essentiellement des Offices, comprenaient des collections diverses (minéraux, coquillages ...), des curiosités de sciences naturelles de l'époque des Médicis, les instruments de Galilée, les appareils de l'Accademia del Cimento et quatre figures de cire du sculpteur Giulio Gaetano Zumbo.

Voulant élargir le musée aux domaines de l'astronomie et de la météorologie, Pierre Léopold demanda en 1780 à l'architecte Gaspare

Paoletti (qui avait déjà participé à la transformation du palais) de construire l'Osservatorio Astronomico (la « petite tour ») qui devait donner plus tard à l'ensemble du complexe le nom de « Specola » (observatoire). Il s'agissait d'un projet ambitieux qui agrandissait considérablement le bâtiment et fut achevé en 1789, malgré les avis divergents de nombreux experts, lesquels auraient préféré bâtir une nouvelle construction sur les collines de l'Acetri. La même année, une partie du parc Boboli fut intégrée au jardin botanique du musée (ill. p. 8).

A la mort de son frère Joseph, Pierre Léopold lui succéda à la tête de l'Empire en 1790 et céda la Toscane à son fils cadet Ferdinand III (1769–1824) qui était bien loin de posséder la largeur d'esprit de son père et son habileté à gouverner. Pour couronner le tout, la Toscane fut prise par les Français en 1799. Après maintes complications, elle devint en 1801 le royaume d'Etrurie et fut remise aux Bourbon-Parme. Durant ces années, le musée organisa des cours dans les disciplines scientifiques, qui se poursuivirent après la restauration des Lorrains en 1814.

Le musée vécut une période mouvementée sous Ferdinand III. Il perdit son importance scientifique qui l'avait caractérisé à ses débuts, époque où il était considéré comme l'un des plus grands centres du savoir européen, ce qu'attestaient d'ailleurs des visiteurs étrangers aussi illustres que Goethe et Bernouilli. A l'instar de son père, Ferdinand III entreprit des transformations importantes dans le palais : en 1820, un

1793 catalogue of the wax models

Katalog der Wachspräparate von 1793

Catalogue des préparations en cire de 1793

corridor reliant la Specola à l'aile de la Méridienne, un pavillon du palais Pitti, fut construit sous la direction de l'architecte Pasquale Poccianti. Ce nouveau passage prolongeait jusqu'à la Specola le corridor Vasari existant qui conduisait du palais Vecchio au palais Pitti en passant par les Offices.

A la mort de Ferdinand III en 1824, le grand-duché passa aux mains de son fils Léopold II (1797–1870), surnommé gentiment « Canapone » par les Florentins en raison de ses cheveux blonds. C'est à lui que revient le mérite d'avoir donné un nouvel élan aux études scientifiques, en particulier à celles que l'on pouvait appliquer concrètement comme dans l'agriculture par exemple. C'est également sous sa régence que fut construite la Tribuna di Galileo, hommage au grand chercheur, qui fut inaugurée à Florence, en 1841, à l'occasion du troisième congrès des scientifiques italiens. La Tribuna est une grande salle au premier étage du bâtiment en partie reconstruit par l'architecte Giuseppe Marelli. Les travaux commencés en 1830 ne prévoyaient à l'origine qu'une abside supplémentaire dans une salle déjà existante, mais les plans furent modifiés à la demande du grand-duc. Voulant honorer avec grandeur la mémoire de l'illustre savant, il décida de lui consacrer la salle entière qui abriterait, outre une statue de Galilée, tous les objets que l'on avait conservés de lui ainsi que ses instruments se trouvant à l'Accademia del Cimento. La construction de la Tribuna, l'un des rares témoignages du néoclassicis-

A page of the register recording receipts for corpses from the hospital

Registerseite mit Vermerk der Eingänge der Leichname aus dem Krankenhaus

Page du registre avec les indications des arrivées des cadavres provenant des hospices

me à Florence, entraîna d'importantes modifications dans l'architecture du palais : les étages inférieurs furent transformés et la cour fut en partie couverte. On fit venir des peintres et des sculpteurs de la région pour décorer la salle recouverte entièrement de marbre de Toscane.

L'Istituto di Studi Superiori e di Perfezionamento (institut d'études supérieures et de perfectionnement), transformé en 1923 en université royale, fut fondé en 1859 après la chute de Léopold II, le dernier grand-duc de Toscane. Evénement déjà important en soi, la fondation de l'Institut a marqué par ailleurs pour le musée le début de son démembrement en différents départements qui, en raison du nombre toujours croissant des étudiants, durent s'installer en d'autres lieux avec leurs collections et leurs bibliothèques. Seul le département de physique et de sciences naturelles du musée demeura au siège de l'Institut. Malgré l'opposition de nombreux scientifiques de l'époque, le bâtiment historique de la via Romana n'abrita plus finalement que les collections zoologiques et la plus grande partie de la céroplastie anatomique.

View of Room XXVII

Gesamtansicht des Saals XXVII

Vue d'ensemble de la salle XXVII

Page · Seite · Page 27:

G.G. Zumbo:
Il Triunfo del Tempo

The Triumph of Time (Detail)

Der Triumph der Zeit (Detail)

Le Triomphe du Temps (Détail)

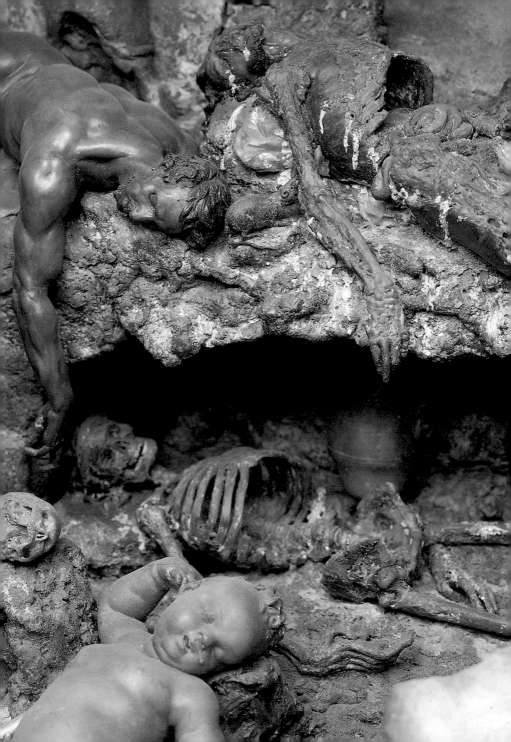

Human Anatomy

Die Anatomie des Menschen

L'Anatomie humaine

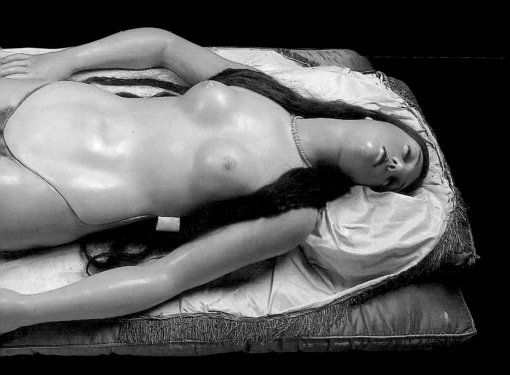

The Anatomy of the Human Body
– A unique collection of the late 18th century
Monika v. Düring

This unique collection of anatomical wax models from the museum 'La Specola', which is embedded in the tradition of European thought, gives us great insight into the knowledge and understanding of the anatomy of the human body as it existed at the end of the 18th century. If one compares the wax models with the representation of anatomical sections in woodcuts and copperplate engravings, it is clear that progress had been made since the traditional anatomical sections and illustrations of the 16th and 17th centuries, and that the production of these specimens was based upon the earlier examples.

These wax models in their three-dimensional form represent for the first time the original specimen much more accurately than a flat drawing could possibly do. The fascination of these specimens lies in the precision with which the details of the anatomical structure are reproduced. What is more, the artistic presentation is so perfected that in the model the whole body is felt to be alive — an impression which results from the representation of the human body in typical poses and gestures and complete refusal to depict a dead body. The form and shape of the human body thus appears as a living unit, with the greatest possible economy of power. Those who observe pictures of the models as much as those who visit the museum are equally impressed by the esthetic quality of human anatomy.

These models do not only represent one of the earliest macroscopic collections, but also one of the most manyfold. It is an impressive record of the skeleton and locomotor apparatus, the internal organs, the cavities of thorax, abdomen and pelvis, the circulatory and lymphatic systems, the central and peripheral nervous systems – including the sense organs – together with a large number of models depicting the relationship of these various entities in the different regions and cavities of the body.

These many exemplary specimens take the visitor on a voyage of discovery through the inner mysteries of our bodies, right down into the deeper regions where organs, vessels and nerves lie hidden. While learning anatomy, the examination of such specimens as these provides the student with a wealth of pictorial detail, bringing before his or her inner eye the image of a "transparent man".

*Page · Seite ·
Page 28–29:*

Whole body specimen of a pregnant woman. The model can be taken apart.

Zerlegbares Ganzkörperpräparat einer Schwangeren

Préparation démontable du corps entier d'une femme enceinte

[Ostetricia, 968]

This encyclopaedic collection, however, contains not only models for the scientific teaching of anatomy, but also models which the viewer initially regarded with displeasure and consternation. In this context one should realise that the burghers of that time were both enlightened and interested. A dissection was regarded and expirienced as a special public occasion which one not only attended but paid to attend. The promoters for their part likewise strove to satisfy the curiosity and sensationalism of the visitor, for which spectacular displays were particularly suitable.

In this presentation, the Florentine collection is for the first time made available to a wider readership in the form of a complete edition of colored illustrations. Even today it is of practical use. It offers both to the interested layman and to the medical student a variety of interesting experiences. The latter can test his anatomical knowledge by naming the various structures depicted, and will further recognize misinterpretations based upon the scientific knowledge of the time. But it will also become apparent how much detail was already known even in those days, and at the same time we become aware of the advances medicine has made with the development of new techniques of visual display.

Die anatomische Gestalt des Menschen
– Ein einmaliges Zeitdokument des ausgehenden 18. Jahrhunderts
Monika v. Düring

Diese einmalige Modellsammlung der anatomischen Wachse des Museums La Specola vermittelt, eingebettet in die Tradition der europäischen Geistesgeschichte, den Erkenntnis- und Wissensstand der Anatomie des menschlichen Körpers im ausgehenden 18. Jahrhundert. Vergleicht man die Wachspräparate mit den Darstellungen anatomischer Sektionen auf Holzschnitten und Kupferstichen, wird deutlich, daß die anatomische Sektions- und Abbildungstradition des 16. und 17. Jahrhunderts fortgeschrieben wurde und man sich bei der Herstellung der Präparate an diesen Vorbildern orientierte.

In Form des gestalteten Wachsmodells gewinnt das Präparat hier zum ersten Mal eine dreidimensionale Dimension und kommt somit dem Originalpräparat sehr viel näher als die zweidimensionale Buchabbildung. Das Faszinierende dieser Präparate liegt in der Genauigkeit, mit der die Details der anatomischen Strukturen wiedergegeben werden. Darüber hinaus ist die künstlerische Darstellung so perfektioniert, daß der tote Körper im Modell als lebendig empfunden wird – ein Eindruck, der durch die Darstellung des menschlichen Körpers in typischen Posen und Gesten und durch den vollständigen Verzicht auf die Darstellung eines vom Tode gezeichneten Körpers entsteht. Die Form und Gestalt des menschlichen Körpers wird auf diese Weise zu einer vitalen Einheit von höchster Ökonomie der Kräfte. Die Modelle vermitteln dem Betrachter der Abbildungen genau wie dem Besucher des Museums eine Humananatomie von besonderer Ästhetik.

Diese Modellsammlung ist nicht nur eine der ersten makroskopischen Sammlungen, sondern auch eine der vielfältigsten. Auf beeindruckende Weise dokumentieren dies die zahlreichen anatomischen Präparate des Skelett- und Bewegungsapparates, der inneren Organsysteme, des Brust-, Bauch- und Beckenraums, des Blut- und Lymphgefäßsystems, des zentralen und peripheren Nervensystems – einschließlich der Sinnesorgane – sowie eine große Anzahl von Modellen, die die Komplexität der räumlichen Beziehungen verschiedener Systeme in einer Körperregion oder Körperhöhle wiedergeben. Die Vielzahl der Detailpräparate führt den Betrachter auf eine Entdeckungsreise durch das Innere unseres Körpers, systematisch von der Oberflächenanatomie bis

in die tieferen Regionen der Körperhöhlen mit Organen, Gefäßen und Nerven. Im anatomischen Unterricht schulte das Studium derartiger Präparate das räumliche Vorstellungsvermögen und half den Studenten, sich anhand des Modells den „gläsernen Menschen" vor seinem geistigen Auge vorzustellen.

Die enzyklopädisch reiche Sammlung enthält allerdings nicht nur Demonstrationsobjekte für den wissenschaftlichen anatomischen Unterricht, sondern auch Modelle, die der Betrachter aufgrund einer drastischen Darstellung zunächst mit Befremden und Betroffenheit betrachtet. Hierzu sollte man wissen, daß der Bürger der damaligen Zeit aufgeklärt und interessiert war. Eine Sektion wurde als ein besonderes öffentliches Ereignis empfunden und erlebt, das man besuchte und für das Eintritt zu bezahlen war. Die Veranstalter waren andererseits auch bemüht, die Neugier und Sensationslust der Besucher zu befriedigen, wozu spektakuläre Darstellungen am besten geeignet waren.

In der hier vorgelegten Ausgabe wird die Florentiner Sammlung erstmalig einem breiten Leserkreis als komplette Farbtafelsammlung zugänglich gemacht. Auch heute noch ist das Werk von praktischem Nutzen. Es bietet sowohl dem interessierten Laien wie auch dem angehenden jungen Arzt vielfältige Anregungen, der Medizinstudent kann durch Benennung der einzelnen Strukturen sein anatomisches Wissen überprüfen und wird natürlich auch die historisch bedingten Fehlinterpretationen erkennen. Im Vergleich wird deutlich, über welch genauen Detailkenntnisse man bereits zur damaligen Zeit verfügte, und gleichzeitg werden wir der Fortschritte gewahr, die die Medizin mit der Entwicklung neuer bildgebender Verfahren gemacht hat.

L'Anatomie du corps humain
– Une collection unique de la fin du XVIIIe siècle
Monika v. Düring

La collection, unique en son genre, des cires anatomiques de la Specola, replacée dans le contexte de l'histoire des sciences de l'Homme en Europe, renseigne sur l'état des connaissances en anatomie humaine à la fin du XVIIIe siècle. La comparaison des préparations en cire avec les représentations des dissections anatomiques gravées sur bois ou sur cuivre permet de constater que la tradition des dissections et de l'iconographie anatomique des XVIe et XVIIe siècles a non seulement été maintenue, mais a influencé l'élaboration des modèles en cire.

Sous la forme du modèle en cire, l'illustration anatomique devient pour la première fois tridimensionnelle, et par là se rapproche beaucoup plus de la préparation originale que de la représentation plane. Le caractère fascinant des cires de la Specola tient à la précision avec laquelle sont restitués les détails des structures anatomiques. La représentation artistique, poussée à la perfection, fait percevoir le modèle cadavérique comme un sujet vivant. Cette impression résulte de la volonté de l'artiste de faire abstraction des stigmates de la mort ; à leur place sont évoqués des positions et des gestes de la vie courante laissant transparaitre l'unicité des formes et des fonctions vitales. Ces modèles procurent à l'observateur le sentiment de cette esthétique particulière qu'éprouve le visiteur d'un musée d'anatomie.

Cette collection de modèles en cire est non seulement l'une des plus anciennes collections anatomiques macroscopiques, mais aussi l'une des plus grandes et des plus variées. Les nombreuses préparations anatomiques apportent des données remarquables sur le squelette et l'appareil locomoteur, les viscères du thorax, de l'abdomen et du petit bassin, les systèmes circulatoires sanguin et lymphatique, les systèmes nerveux central et périphérique, les organes des sens ... Un grand nombre de modèles restituent la complexité des rapports topographiques entre les différents éléments anatomiques d'une région donnée du corps ou de l'une des cavités naturelles. La multiplicité des préparations concernant des régions isolées permet à l'observateur une exploration systématique du corps depuis l'anatomie de surface jusqu'aux régions profondes où sont logés les organes, vaisseaux et nerfs. Au cours de l'enseignement de l'anatomie, l'étude de telles préparations

permet l'acquisition de la notion de volume et la représentation mentale de « l'homme transparent ».

A côté des objets de démonstration pour l'enseignement de la science anatomique constituant cette collection encyclopédique, se trouvent encore des modèles qui peuvent déconcerter. voire troubler le spectateur d'aujourd'hui en raison de leur représentation radicale. Il faut savoir que l'« honnête homme » du XVIIIe siècle était instruit, et que la dissection était une manifestation publique suivie avec intérêt dont le spectacle était payant. Les organisateurs s'efforçaient en conséquence de satisfaire la curiosité et le goût du sensationnel des visiteurs par des représentations spectaculaires.

Dans le présent ouvrage, la collection de cires anatomiques de la Specola de Florence est rendue, pour la première fois, accessible à un large public sous la forme d'une série complète de photographies en couleur. A l'heure actuelle, un tel ouvrage présente encore un intérêt pratique, et ouvre de nombreuses perspectives tant au profane intéressé qu'au médecin. l'étudiant en médecine pourra notamment tester ses connaissances anatomiques en identifiant et nommant chaque structure, mais aussi en reconnaissant les fautes d'interprétation liées au contexte historique. Par comparaison avec les connaissances précises disponibles à l'époque de cette collection, il est possible de mesurer les progrès de la médecine réalisés grâce au développement de nouvelles techniques.

Head of whole
body specimen of
a pregnant woman.
The model can be
taken apart.

Kopfstudie des
zerlegbaren Ganz-
körperpräparates
einer Schwangeren

Tête d'une prépara-
tion démontable du
corps entier d'une
femme enceinte

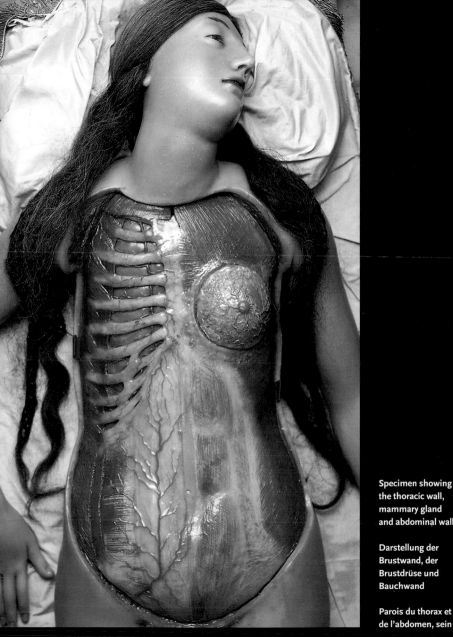

Specimen showing
the thoracic wall,
mammary gland
and abdominal wall

Darstellung der
Brustwand, der
Brustdrüse und
Bauchwand

Parois du thorax et
de l'abdomen, sein

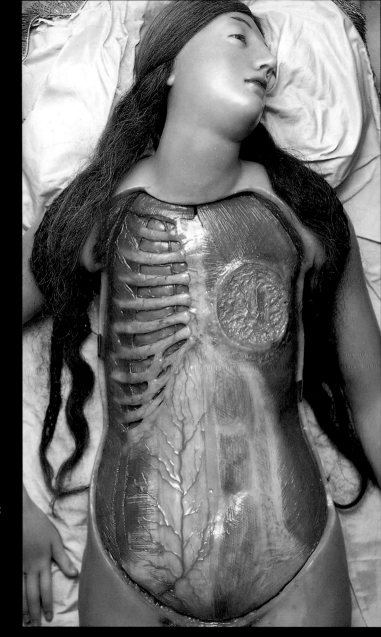

Specimen showing
the thoracic and
abdominal walls

Darstellung der
Brust- und Bauch-
wand

Parois du thorax et
de l'abdomen

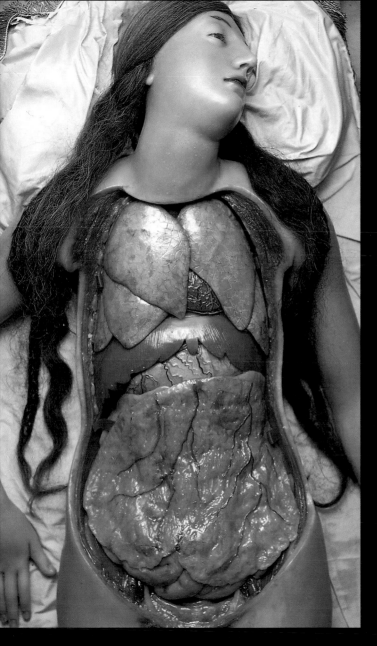

View into the
opened thoracic
and abdominal
cavities. In the
thorax the right
and left lungs can
be seen, and part
of the anterior sur-
face of the heart.
The intestines are
hidden behind the
greater omentum.

Einblick in die
eröffnete Brust-
und Bauchhöhle.
In der Brusthöhle
sind rechter und
linker Lungenflügel
sowie ein Teil der
Herzvorderfläche
zu erkennen. Die
Darmschlingen
sind vom großen
Netz bedeckt.

Viscères du thorax
et de l'abdomen :
cœur et poumons
vus de l'avant,
anses de l'intestin
grêle recouvertes
par le grand
épiploon

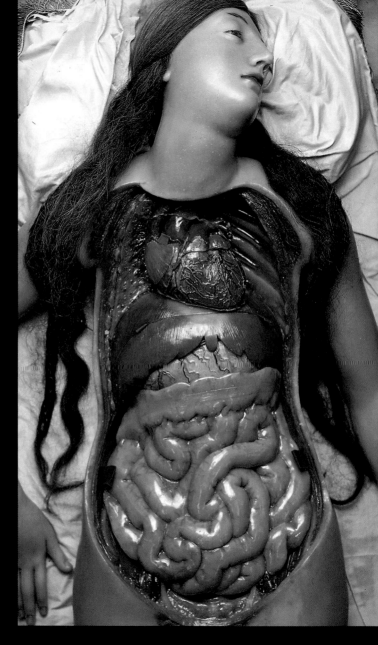

Specimen of the heart showing the coronary vessels and the great vessels that enter and leave the heart. In the abdominal cavity the greater omentum has been removed.

Präparation des Herzens mit Darstellung der Herzkranzgefäße und der abgehenden großen Gefäße aus dem Herzen. In der Bauchhöhle ist das große Netz entfernt.

Viscères du thorax et de l'abdomen : cœur, vaisseaux coronaires, gros vaisseaux de la base du cœur, ablation du grand épiploon

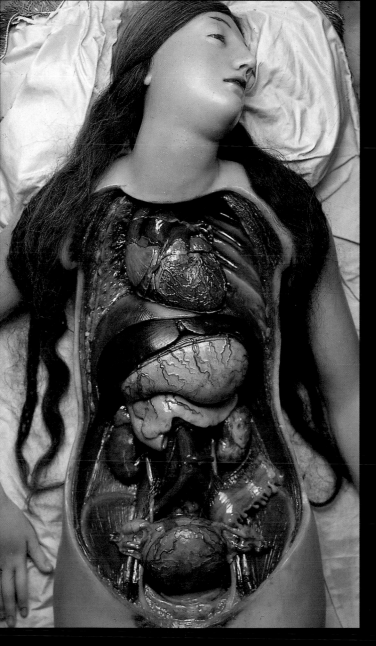

Display showing
the organs in the
upper part of the
abdomen, such as
the stomach, liver
and duodenum,
and also the right
and left kidneys,
the right adrenal
gland, the abdomi-
nal aorta and the
uterus

Blick auf die Ober-
bauchorgane wie
Magen, Leber und
Zwölffingerdarm
sowie die rechte
und linke Niere, die
rechte Nebenniere,
die Bauchschlag-
ader und die
Gebärmutter

Viscères de l'abdo-
men : estomac,
foie, duodénum,
reins, glande surré-
nale droite, utérus

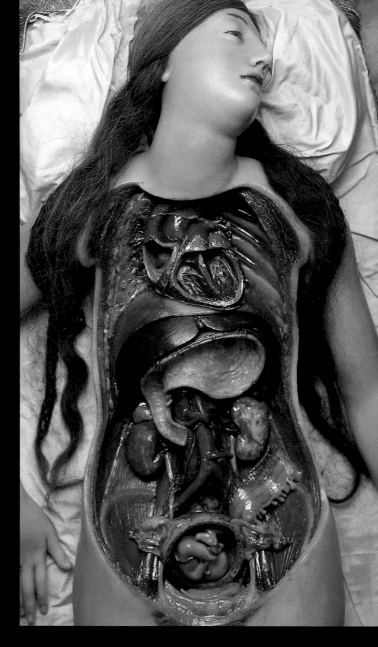

The right atrium,
ventricles, stom‐
ach, duodenum
and uterus have
been opened

Eröffnung des
rechten Herzvor‐
hofes der Herz‐
kammern, des
Magens, des Zwölf‐
fingerdarmes und
der Gebärmutter

Viscères du thorax
et de l'abdomen :
ouvertures de
l'oreillette droite,
des ventricules,
de l'estomac, du
duodénum et de
l'utérus

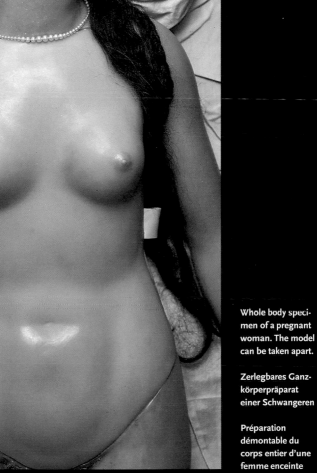

Whole body specimen of a pregnant woman. The model can be taken apart.

Zerlegbares Ganzkörperpräparat einer Schwangeren

Préparation démontable du corps entier d'une femme enceinte

Osteologia et Arthrologia

Bones and Joints
Knochen und Gelenke
Squelette et articulations

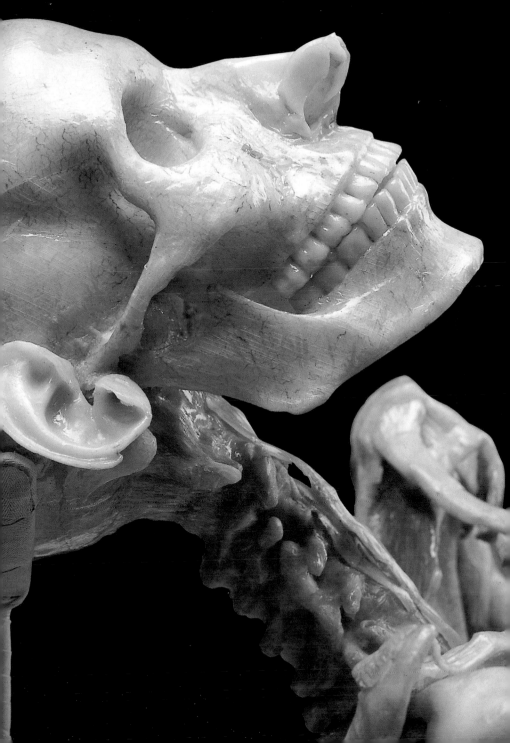

Skeleton humanum

Human Skeleton

Menschliches Skelett

Squelette humain

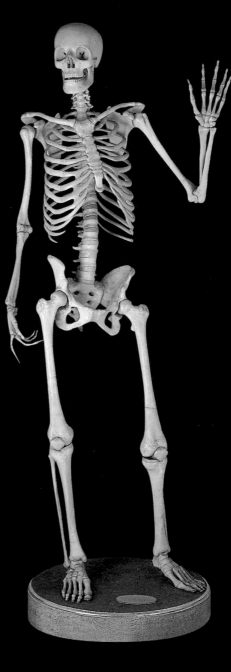

Pages · Seiten · Pages 44–45:

Detail from pages 52–53

Detail der Seiten 52–53

Détail des pages 52–53

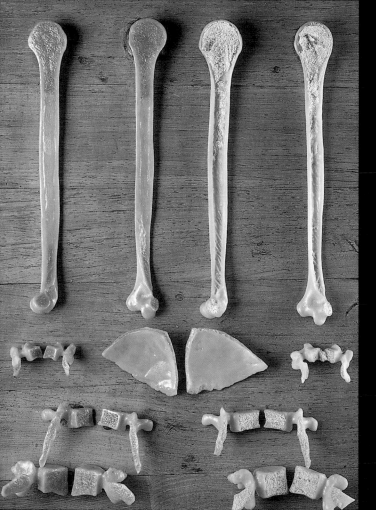

Internal structure
of long bones, skull
bones and verte-
bral bodies

Innere Struktur von
Röhrenknochen,
Schädelknochen
und Wirbelkörpern

Structure interne
d'os longs, d'os
du crâne, et de
vertèbres

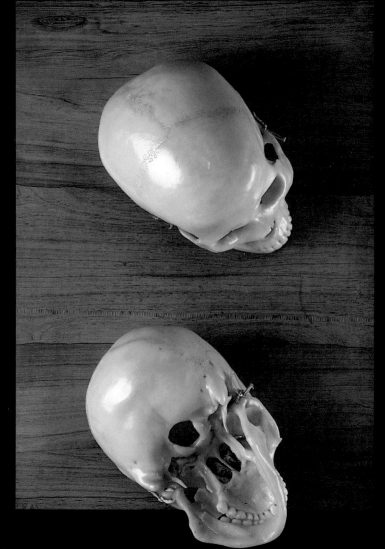

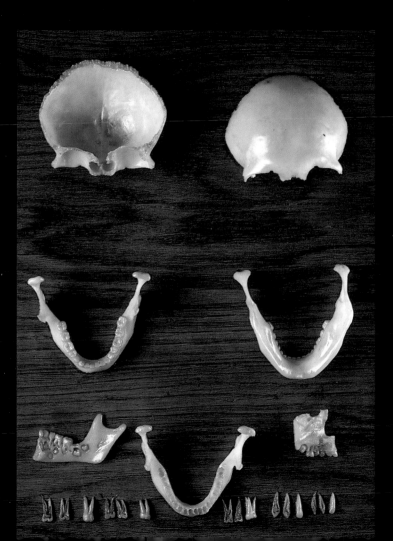

Upper specimen:
two views of the
frontal bone. Lower
specimen: lower
jaw bone with
teeth. Left: milk
teeth with tooth
germs

Obere Präparate:
Stirnbein in zwei
Ansichten. Untere
Präparate: Unter-
kieferknochen mit
Zähnen; links:
Milchgebiß mit
Zahnanlagen

En haut : os frontal
vu de l'avant et de
l'arrière. En bas :
mandibules
d'adultes et
d'enfant avec
la dentition

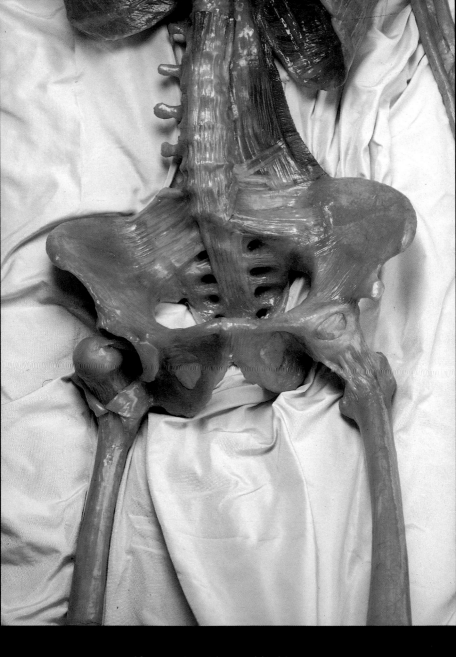

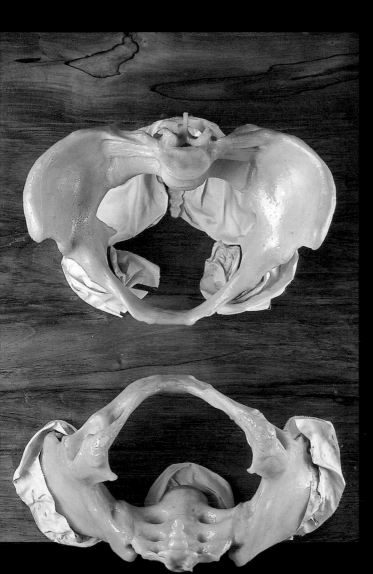

Pelvic girdle, consisting of the sacrum and two hip bones, seen from above in the upper specimen and from below in the lower specimen

Beckengürtel bestehend aus Kreuzbein und zwei Hüftbeinen, im oberen Präparat in der Ansicht von vorn oben, im unteren Präparat von unten

Articulations du bassin : vue supérieure (en haut), vue inférieure (en bas)

Whole body specimen showing the ligaments,
joints and some single muscles and tendons

Ganzkörperpräparat mit Darstellung von
Bändern, Gelenken sowie einzelner Muskeln
und Sehnen

Préparation du corps entier représentant les
articulations, les ligaments et quelques muscles
et tendons

[XXVI, 428]

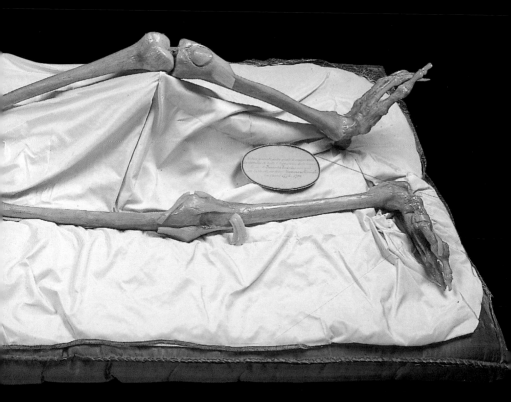

External and internal ligaments of various parts of the vertebral column

Äußere und innere Bandverbindungen in verschiedenen Wirbelsäulenabschnitten

Ligaments de différents segments de la colonne vertébrale

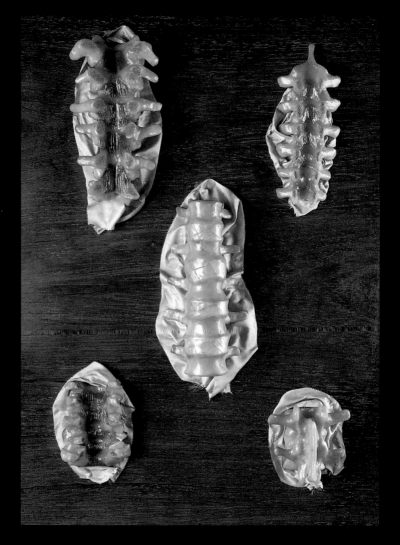

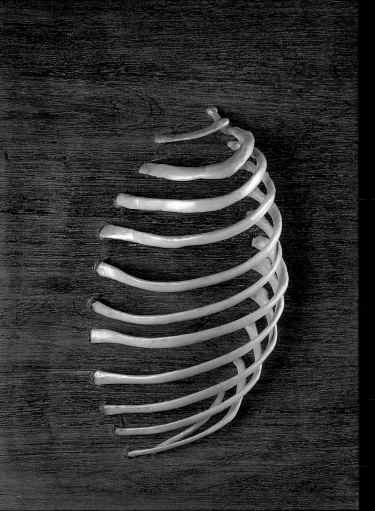

Display showing
the 12 ribs on left
side of thoracic
cage in their
natural position,
seen from the side.
Above: first rib

Darstellung der
12 Rippen der
linken Brustkorb-
seite in natürlichen
Abständen in
der Vorderseiten-
ansicht, erste
Rippe oben liegend

Côtes gauches
vues de côté ;
l'écartement nor-
mal entre les douze
côtes a été respecté
(la première côte
est en haut)

Tendons and
tendon sheaths of
the back of the
hand. Tendinous
sheet of palm, and
the insertions of
tendons of the
flexor and extensor
muscles of the
fingers

Darstellungen
der Sehnen und
Sehnenscheiden
des Handrückens
sowie der Sehnen-
platte der Hand-
innenfläche und
der Ansätze der
Sehnen der Finger-
beuge- und Finger-
streckmuskeln

Articulations de la
main : tendons et
gaines tendineuses
des muscles
fléchisseurs et
extenseurs des
doigts

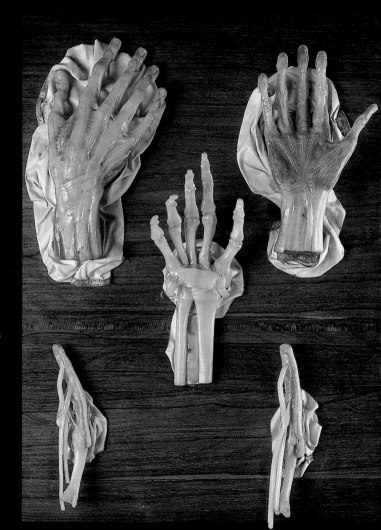

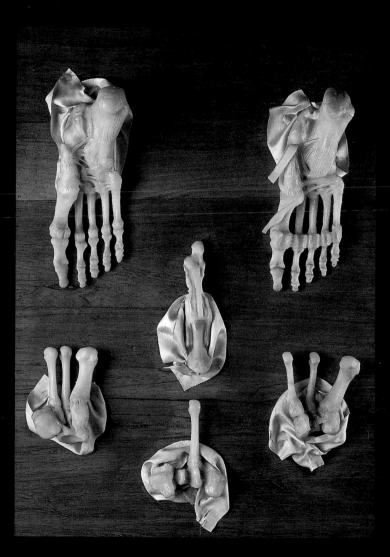

The ligaments of
the ankle joint and
foot

Darstellungen der
Bandverbindungen
der Sprunggelenke
und des Fußes

Articulations du
pied avec les liga-
ments (vue plan-
taire)

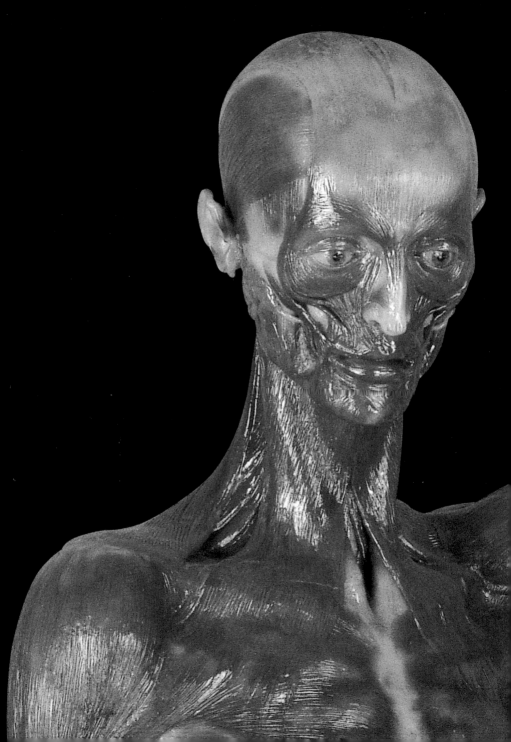

Myologia

Muscles
Muskeln
Muscles

Whole body
specimen display-
ing the superficial
and deep muscles

Ganzkörper-
präparat zur
Darstellung ober-
flächlicher und
tiefer liegender
Muskulatur

Préparation du
corps entier
représentant des
muscles super-
ficiels et profonds

Pages · Seiten ·
Pages 58–59:

Whole body speci-
men displaying the
superficial muscles
(Detail)

Ganzkörperpräpa-
rat zur Darstellung
der oberflächlichen
Muskeln (Detail)

Préparation du
corps entier repré-
sentant les muscles
superficiels (Détail)

[XXV, 444]

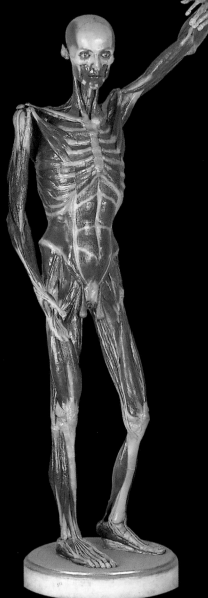

Whole body specimen displaying both the superficial and deep muscles

Ganzkörperpräparat zur Darstellung oberflächlicher und tiefer liegender Muskulatur

Préparation du corps entier représentant des muscles superficiels et profonds

**Muscles of
facial expression,
muscles of
mastication**

**Mimische Muskeln
und Kaumuskeln**

**Muscles peauciers
de la mimique et
muscle temporal**

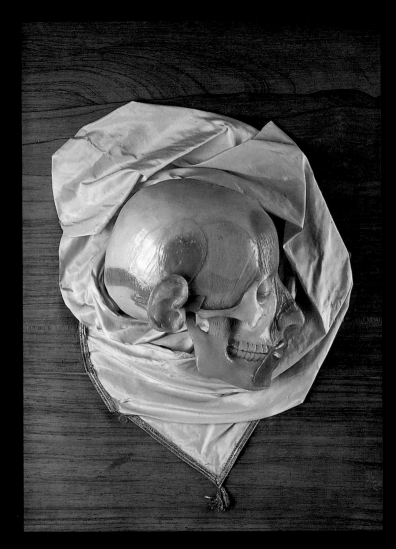

Muscles of facial
expression associ-
ated with the nose,
lips and chin

Mimische Muskeln
im Bereich der
Nase, der Lippen
und des Kinns

Muscles peauciers
de la mimique des
régions des lèvres
et du menton
(en haut)

Middle specimen: longitudinal section through the facial skeleton showing the oral cavity and throat. Above and to the side one can see the nasal conchae, orbital cavities and maxillary sinuses.

Mittleres Präparat: Längsschnitt durch den Gesichtsschädel mit Einblick in Mundhöhle und Rachen. Auf den oben und seitlich gelegenen Präparaten sind die Nasenmuscheln, die Augenhöhlen und die Kieferhöhlen zu erkennen.

Coupe médiane de la face : cavité nasale, cavité buccale, pharynx (au centre). Diverses préparations de muscles de la face

Muscles of the throat seen from behind, including individual muscles of the floor of the mouth

Schlundmuskeln, von hinten gesehen, sowie einzelne Muskeln des Mundbodens

Muscles du pharynx (vus de l'arrière) ; muscles du plancher buccal

Display showing
some muscles of
the back

Darstellung eines
Teiles der Rücken-
muskulatur

Muscles érecteurs
du rachis (spinaux)

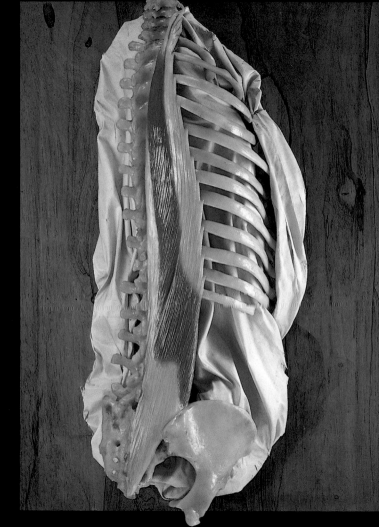

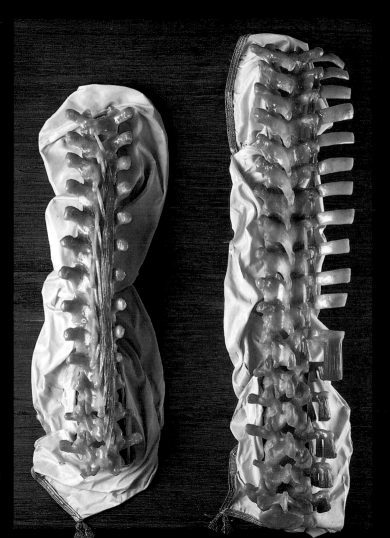

Display showing
deep muscles of
the back in the
thoracic and
lumbar regions
of the vertebral
column

Darstellung eines
Teiles der tiefen
Rückenmuskulatur
im Bereich der
Brust- und Lenden-
wirbelsäule

Muscles profonds
du dos et des
lombes insérés
sur la colonne
vertébrale

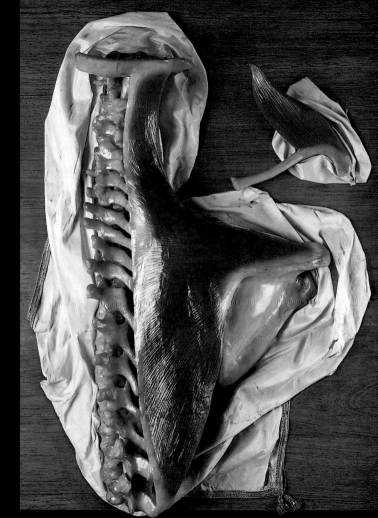

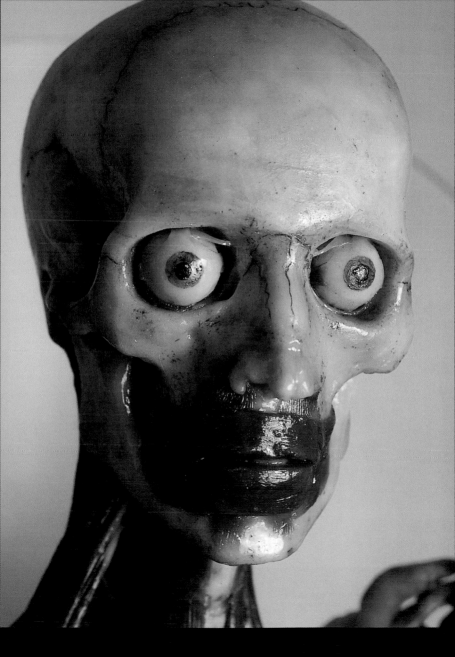

Superficial and
deep muscles
of the anterior
abdominal wall

Oberflächliche und
tiefe Muskeln der
vorderen Bauch-
wand

Muscles abdomi-
naux superficiels
et profonds

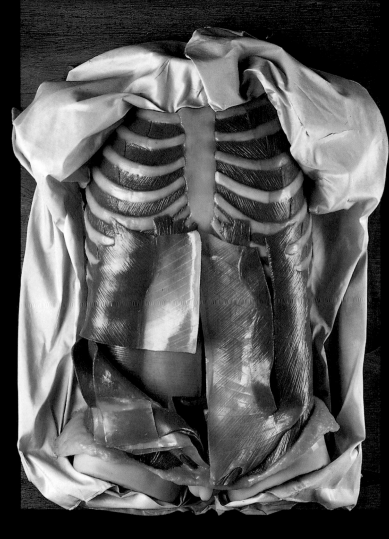

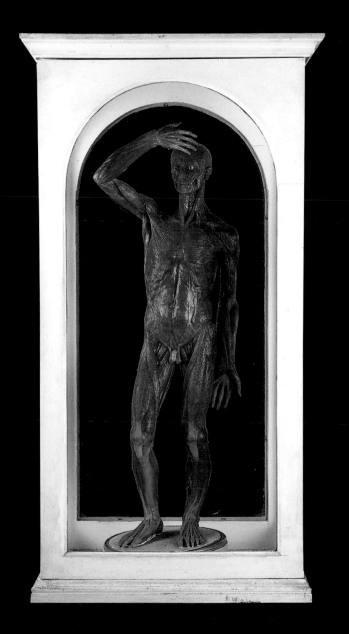

Whole body speci-
men displaying the
superficial muscles

Ganzkörperpräpa-
rat zur Darstellung
der oberflächlichen
Muskulatur

Préparation du
corps entier
représentant des
muscles super-
ficiels

The external and
internal intercostal
muscles

Äußere und innere
Zwischenrippen-
muskeln

Muscles intercos-
taux interne et
externe

Display showing
various intercostal
muscles

Darstellung
verschiedener
Zwischenrippen-
muskeln

Muscle transverse
du thorax (en
haut) ; muscles
intercostaux

The posterior
thoracic and
abdominal walls
seen from in front

Blick von vorn auf
die hintere Brust-
und Bauchwand

Muscles inter-
costaux et carré
des lombes vus
de l'avant

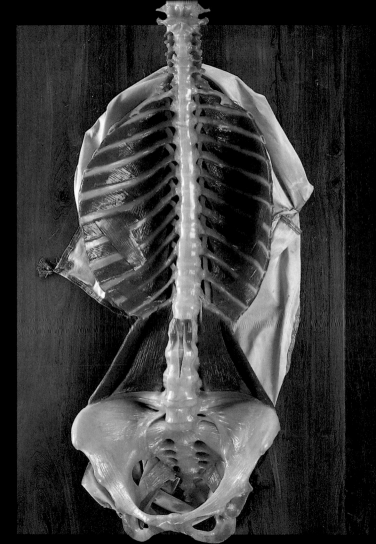

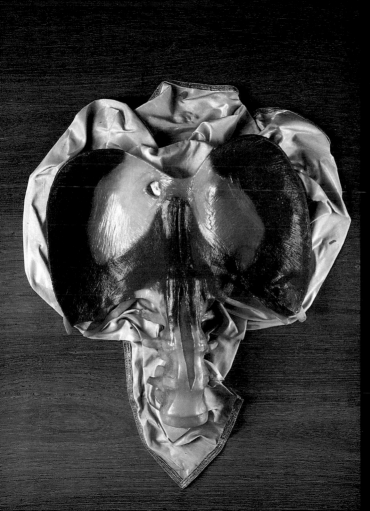

View of the abdominal surface of the diaphragm showing the openings for esophagus, aorta and inferior vena cava

Ansicht auf die dem Bauchraum zugewandte Seite des Zwerchfells mit den Durchtrittsstellen für Speiseröhre, Körperschlagader und untere Hohlvene

Diaphragme avec les orifices de passage de l'œsophage, de l'aorte, et de la veine cave inférieure (vue inférieure)

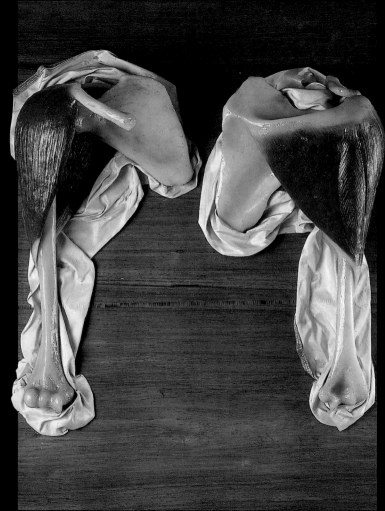

The deltoid muscle

Ansicht des Delta-muskels

Muscle deltoïde

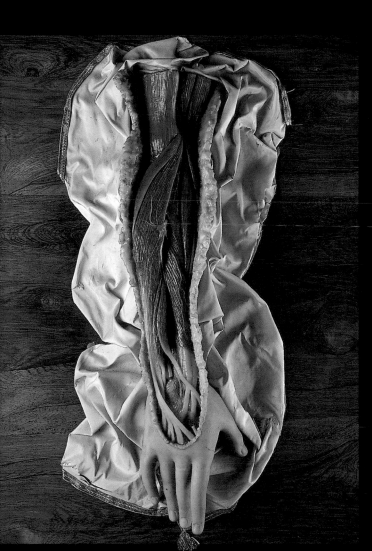

The extensor
muscles of the
hand and thumb
and their tendons

Streckmuskeln
der Hand und des
Daumens und ihre
Sehnen

Muscles exten-
seurs du poignet
et des doigts et
leurs tendons

Display showing
muscles which
contribute to
rotation of the
forearm

Darstellungen von
Muskeln, die an
Drehbewegungen
des Unterarms
beteiligt sind

Muscles de la
loge antérieure
de l'avant-bras
(rond pronateur
et carré pronateur)

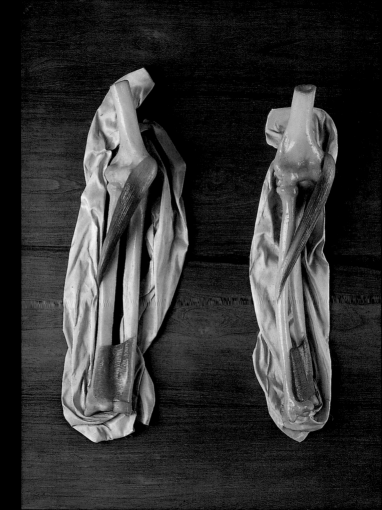

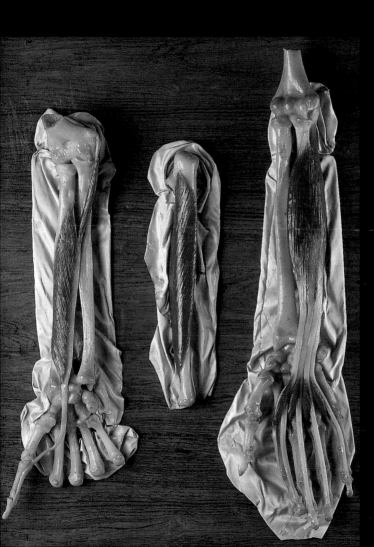

Display showing the long flexor muscles of the fingers with their tendons

Darstellung der langen Fingerbeugemuskeln mit ihren Endsehnen

Muscles long fléchisseur du pouce (à gauche), et fléchisseur profond des doigts (à droite) et leurs tendons

Display showing
the deep muscles
in the hollow of
the hand which
bring about fine
movements of the
fingers

Darstellungen von
tiefen Muskeln der
Hohlhand für fein-
motorische Finger-
bewegungen

Muscles courts
de la main (intrin-
sèques) pour les
mouvements fins
des doigts

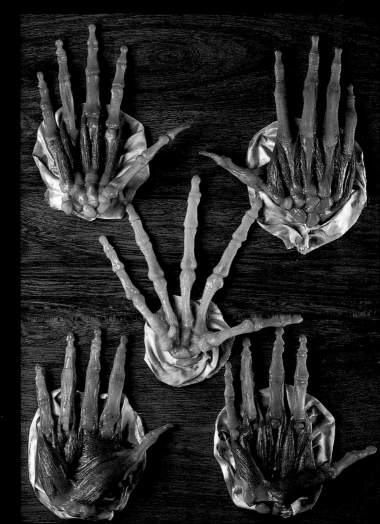

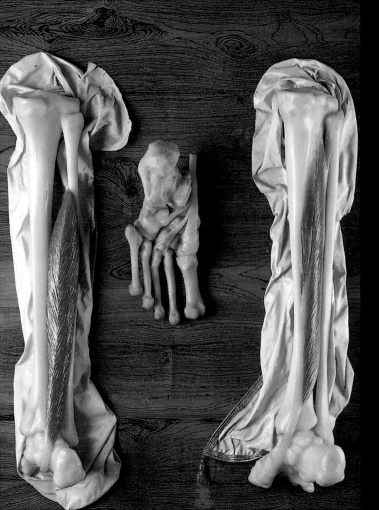

A deep muscle
of the calf that
elevates the inner
border of the foot

Darstellung eines
tiefen Waden-
muskels, der an
der Hebung des
inneren Fußrandes
beteiligt ist

Muscle profond
de la jambe (tibial
postérieur) éléva-
teur du bord
interne du pied

A short muscle on
the outer side of
the lower leg

Darstellung eines
kurzen Muskels an
der Außenseite des
Unterschenkels

Muscle latéral pro-
fond de la jambe
(court fibulaire)

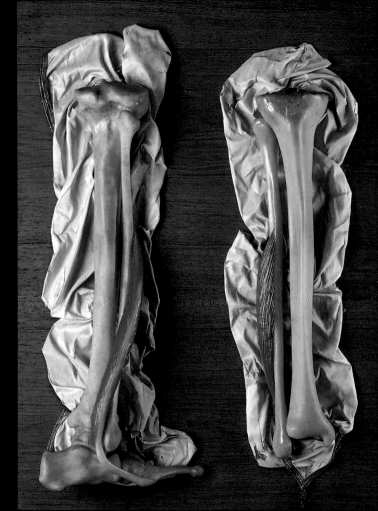

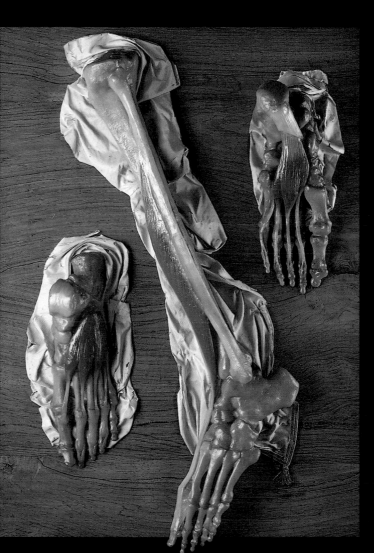

Display showing muscles which contribute to movement of the toes

Darstellung von Muskeln, die an Zehenbewegungen beteiligt sind

Muscles extenseurs et muscle court fléchisseur des orteils

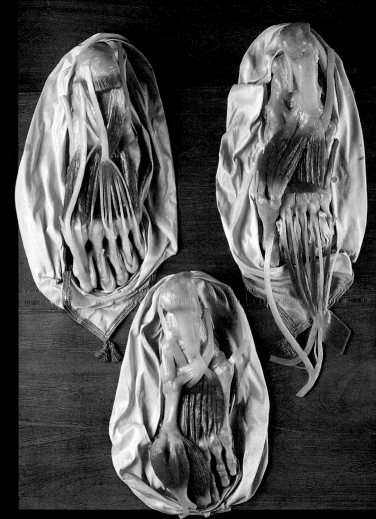

Display showing
muscles and
tendons in the
different layers of
the sole of the foot

Darstellung von
Muskeln und
Sehnen verschie-
dener Schichten
der Fußsohle

Muscles et tendons
de la plante du pied

Whole body specimen with the deep layers of muscles

Ganzkörperpräparat zur Darstellung tiefer Schichten der Muskulatur

Préparation du corps entier représentant des muscles profonds

Whole body specimen with the deep layers of muscles

Ganzkörperpräparat zur Darstellung tiefer Schichten der Muskulatur

Préparation du corps entier représentant des muscles profonds

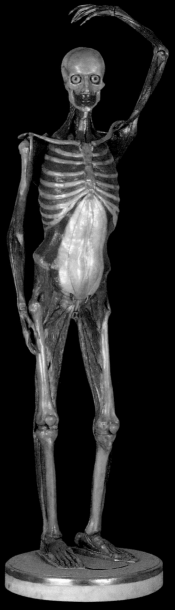

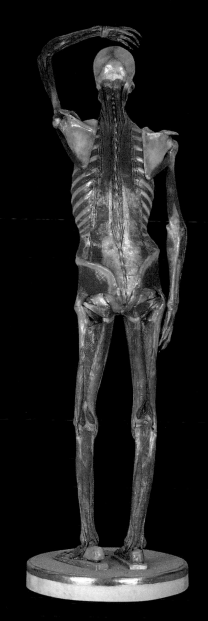

Whole body specimen with the deep layers of muscles

Ganzkörperpräparat zur Darstellung tiefer Schichten der Muskulatur

Préparation du corps entier représentant des muscles profonds

Page · Seite · Page 89:

Detail from pages 90–91

Detail der Seiten 90–91

Détail des pages 90–91

Systema cardiovasculare

Heart and Blood Circulation
Herz und Kreislauf
Cœur, artères et veines

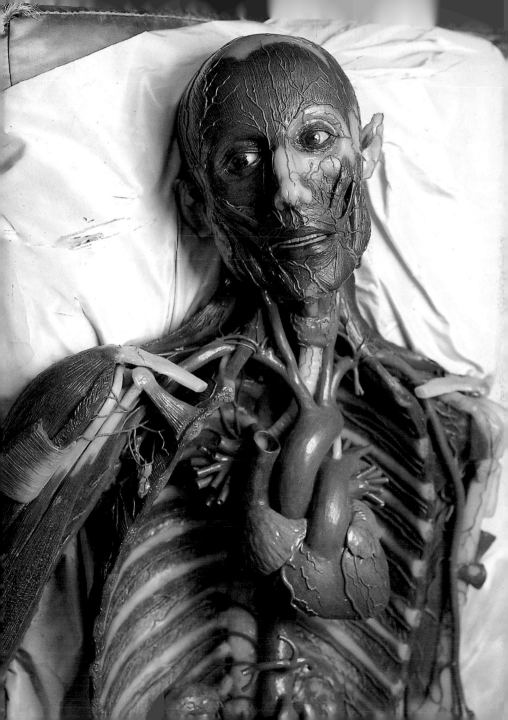

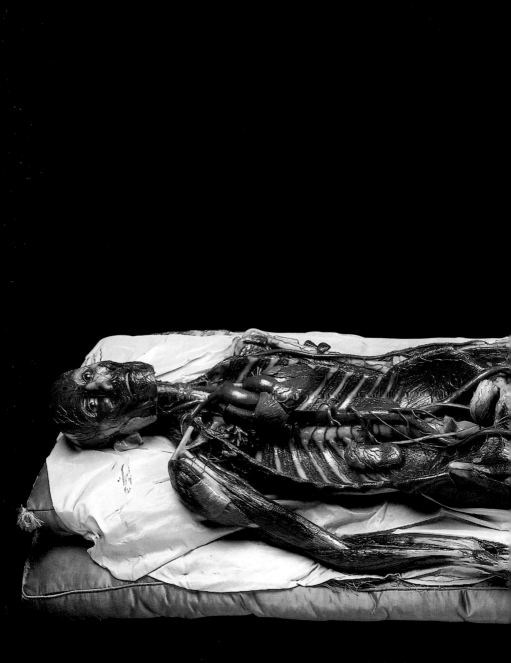

Whole body specimen showing the
arteries

Ganzkörperpräparat mit Darstellung
der Arterien

Préparation du corps entier représentant
les artères

[XXV, 446]

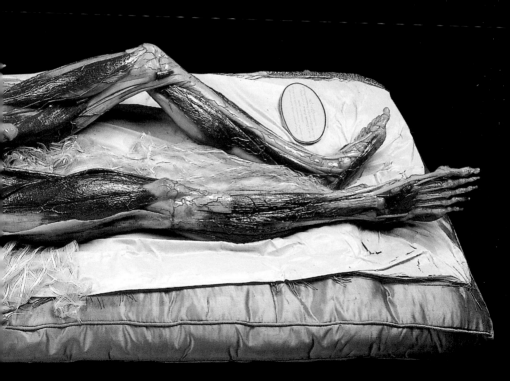

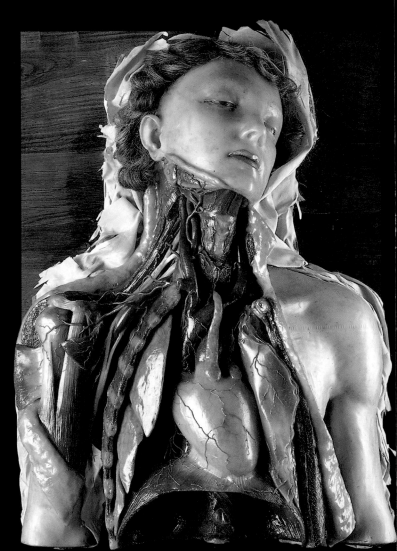

Thoracic cavity laid open to show the heart in its pericardium, the thymus gland and the great vessels. The lungs have been displaced sideways.

Eröffneter Brustraum mit Blick auf das Herz im Herzbeutel, die Thymusdrüse sowie die großen Gefäße und die zur Seite gedrängten Lungenflügel

Cavité thoracique ouverte : péricarde, gros vaisseaux de la base du cœur destinés au cou et aux membres supérieurs, poumons réclinés

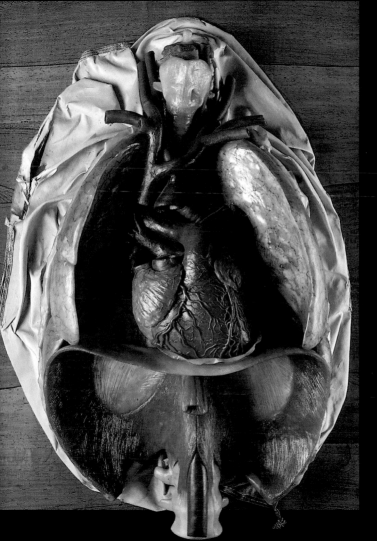

The heart displayed in its natural position in the thoracic cavity. The pericardium has been removed and the lungs displaced sideways.

Darstellung des Herzens in seiner natürlichen Lage im Brustraum. Der Herzbeutel ist enfernt, die Lungenflügel sind zur Seite gedrängt.

Cœur en position naturelle : péricarde enlevé, poumons réclinés

Upper specimen:
anterior aspect of
the heart seen from
the left. A branch
of the left coronary
artery. Lower speci-
men: base of the
heart lying on the
diaphragm

Oberes Präparat:
Ansicht des Her-
zens von links
vorne. Blick auf
einen Ast der lin-
ken Herzkranz-
arterie. Unteres
Präparat: Ansicht
auf die dem
Zwerchfell auf-
liegende Herzbasis

Artères et veines
du cœur (coro-
naires) vus de
l'avant (en haut) et
de l'arrière (en bas)

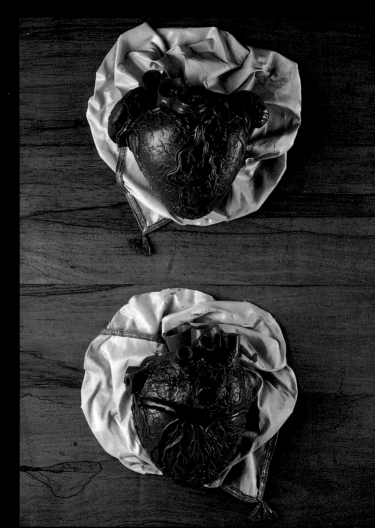

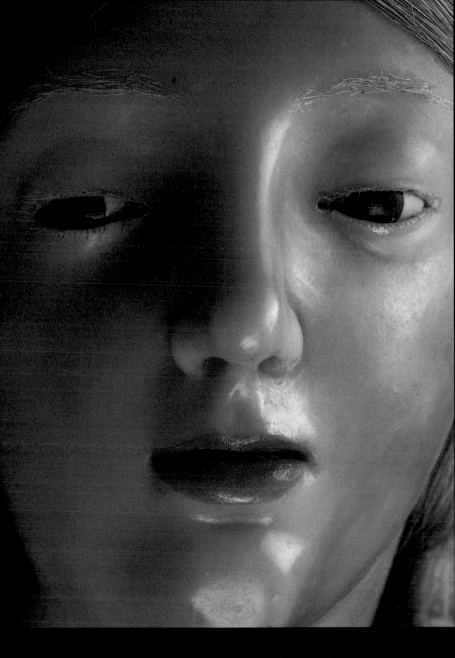

Various views of
the semilunar and
atrioventricular
valves

Verschiedene
Darstellungen
von Taschen- und
Segelklappen

Cœur ouvert :
valves et valvules
atrio-ventriculaires
et semi-lunaires

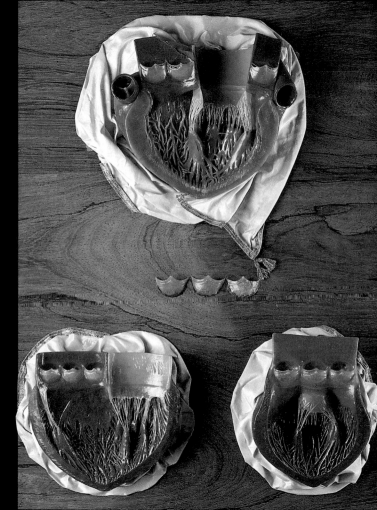

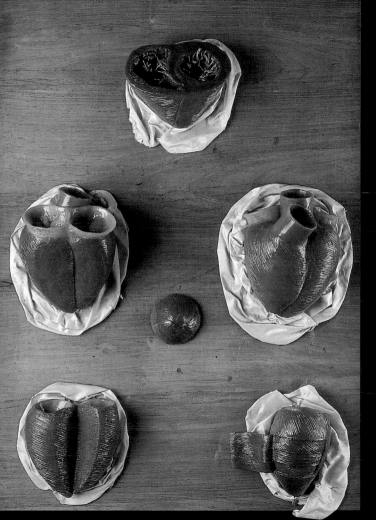

Various views
showing the
arrangement of
the fibers of the
ventricular muscle

Verschiedene
Darstellungen
der Anordnung
der Fasern
der Kammer-
muskulatur

Architecture des
fibres musculaires
des ventricules
(myocarde)

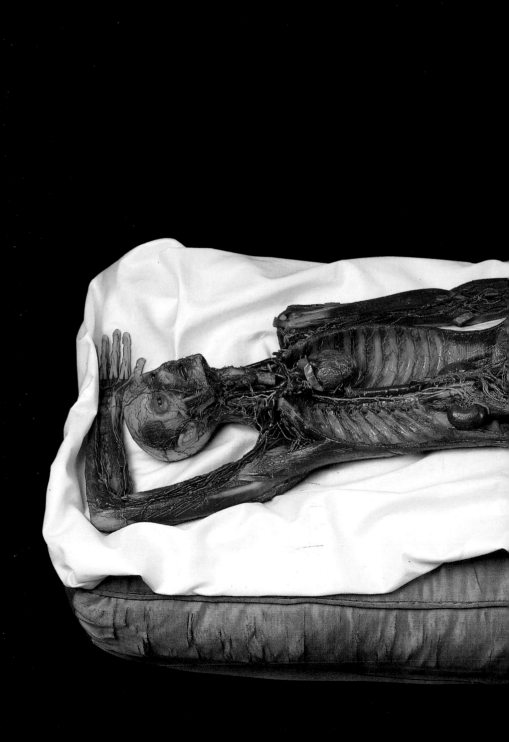

Whole body specimen showing sections of
the vascular system

Ganzkörperpräparat zur Darstellung von
Abschnitten des Gefäßsystems

Préparation du corps entier représentant
différents éléments de l'appareil circulatoire

[DEP. 15, 11]

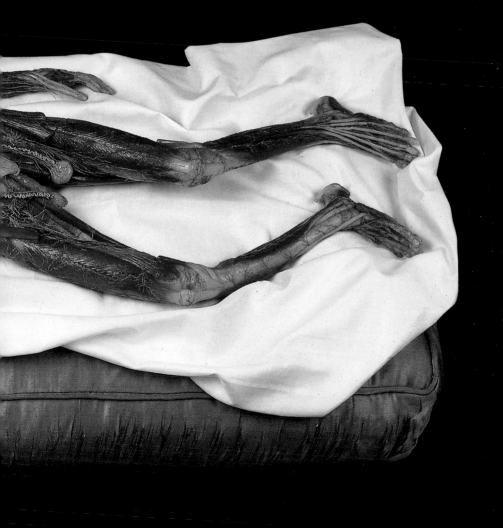

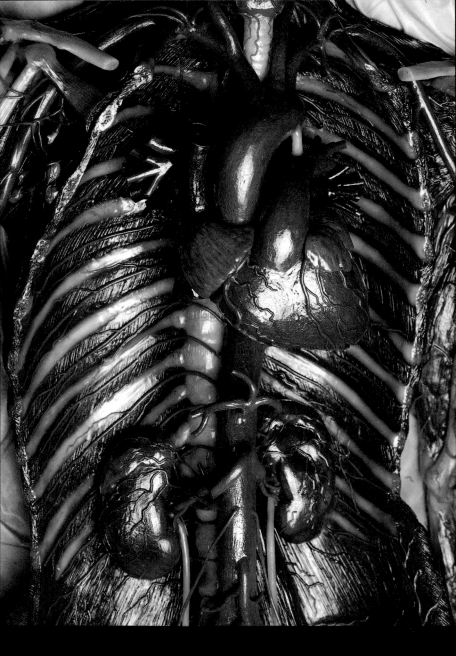

Detail from pages | Detail der Seiten | détail des pages 90–91

Various views of
the aortic arch.
The coronary
arteries arise from
the aortic bulb

**Verschiedene
Darstellungen des
Aortenbogens. Die
Herzkranzgefäße
haben ihren Ur-
sprung im Bereich
der Auftreibung**

**Crosse de l'aorte et
ses branches colla-
térales ; les artères
coronaires naissent
du bulbe aortique**

Demonstration of
the fetal circula-
tion. Below central:
the umbilical vein
and its tributaries
from the placenta

Darstellung des
fötalen Kreislaufes.
Unten in der Mitte:
die Nabelschnur-
vene und ihre
Zuflüsse aus dem
Mutterkuchen

Cœurs de fœtus et
circulation fœtale.
En bas au centre :
veine ombilicale et
veines du placenta

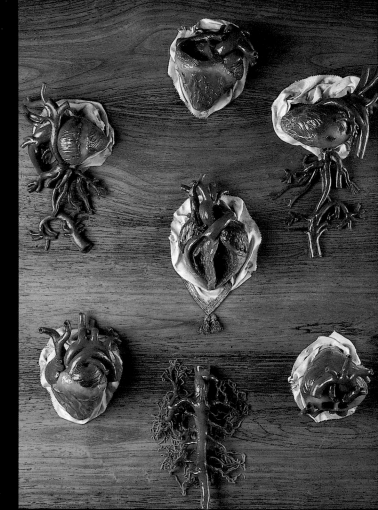

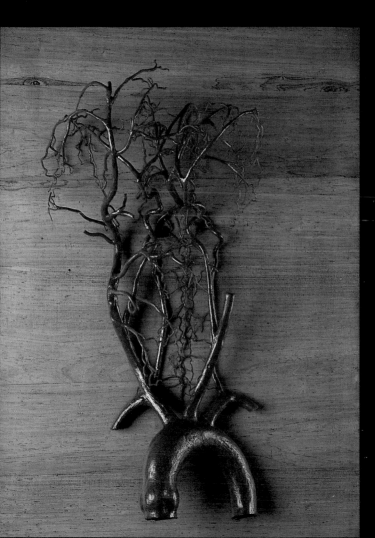

Specimen showing the arteries of the head and neck. On the left side of the model the carotid artery with its branches can be seen taking origin from the aortic arch.

Präparat der Arterien im Bereich des Kopfes und Halses. Links im Bild ist die vom Aortenbogen abzweigende Halsschlagader mit ihren Aufzweigungen dargestellt.

Arbre artériel de la tête et du cou : ramifications de l'artère carotide (à gauche)

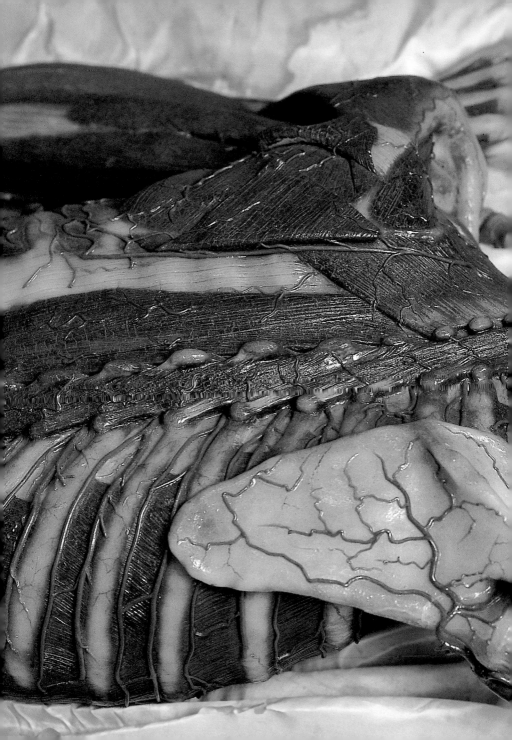

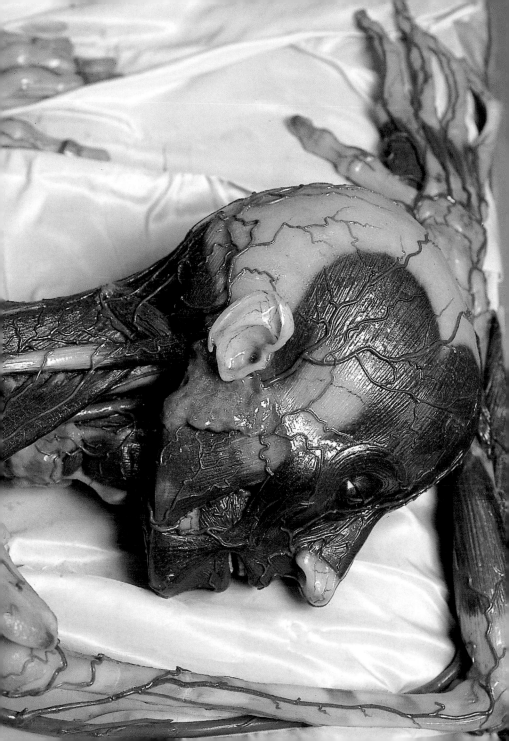

The arteries of the
anterior thoracic
and abdominal
walls

Darstellung der
Arterien der vor-
deren Brust- und
Bauchwand

Artères des parois
antérieures du
thorax et de l'ab-
domen

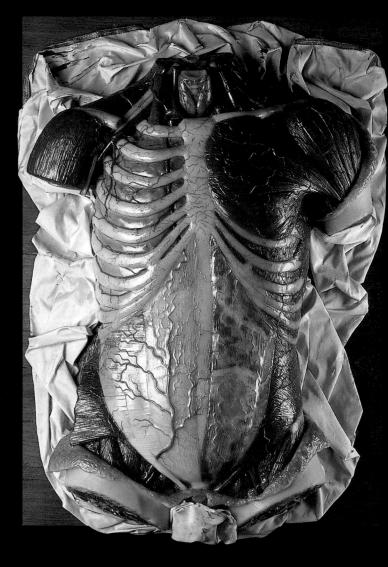

*Pages · Seiten ·
Pages 104–105:*

Whole body speci-
men showing the
arteries (detail)

Ganzkörperpräpa-
rat mit Darstellung
der Arterien
(Detail)

Préparation du
corps entier repré-
sentant des nerfs
et artères (détail)

[XXV, 445]

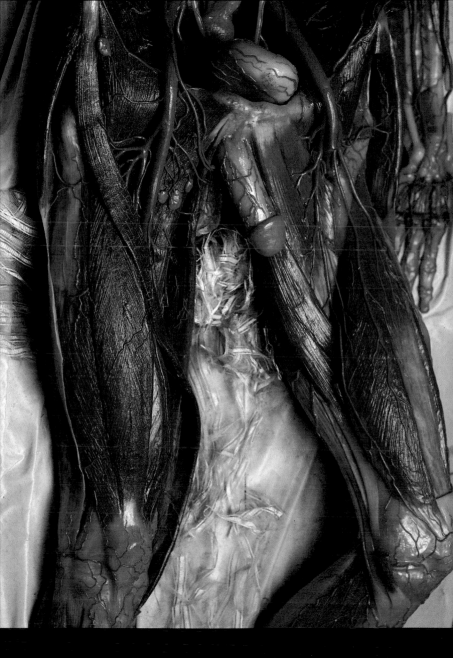

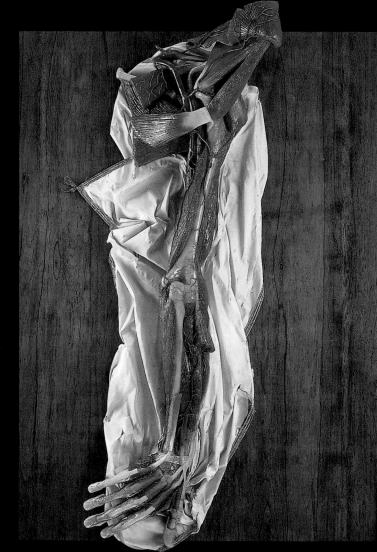

The deep arteries of the upper arm and forearm

Darstellung von tiefen Arterien des Ober- und Unterarmes

Artères du membre supérieur vues de l'arrière

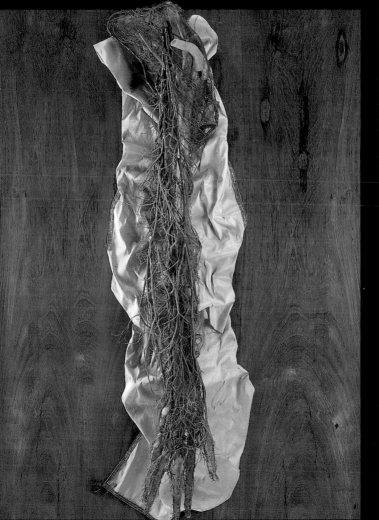

The arteries, veins and nerves of the arm

Darstellung der Arterien, Venen und Nerven des Armes

Artères, veines, et nerfs du membre supérieur projetés sur le squelette

View from in front
of the organs and
arteries of a female
pelvis. The uterus
can be seen lying
between the blad-
der and rectum. All
the organs have
been displaced to
one side to show
their supplying
arteries.

Blick von vorn auf
Organe und Arteri-
en eines weiblichen
Beckens. Zwischen
Harnblase und
Enddarm ist die
Gebärmutter zu
erkennen. Alle
Organe sind zur
Seite gedrängt, um
den Blick auf die
versorgenden Arte-
rien freizugeben.

Artères et viscères
du bassin féminin ;
vessie, utérus, et
côlon réclinés vers
la droite dégageant
le trajet des artères

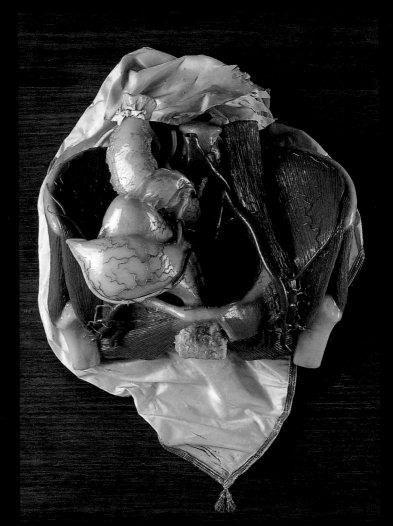

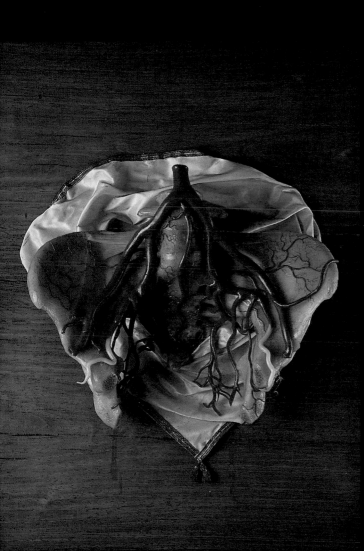

Arteries within the pelvis. The terminal part of an artery on each side is shown in yellow. This is that part of the umbilical artery which becomes obliterated after birth.

Arterien im Bereich des Beckens. Der Endabschnitt einer Arterie beidseits ist gelblich dargestellt. Hierbei handelt es sich um den beim Erwachsenen verschlossenen Teil der Nabelarterie.

Arbre artériel du bassin ; en jaune, segment terminal de l'artère ombilicale oblitéré après la naissance

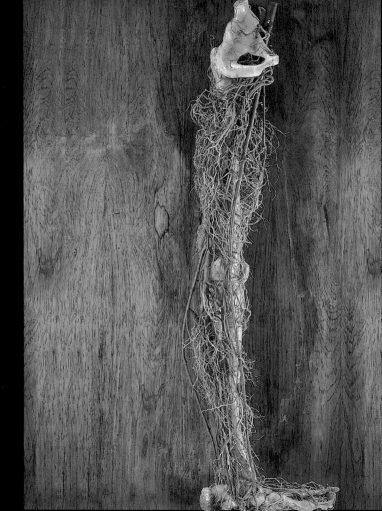

The blood vessels
of the lower limb

Darstellung der
Blutgefäße des
Beines

Artères et veines
du membre in-
férieur projetées
sur le squelette

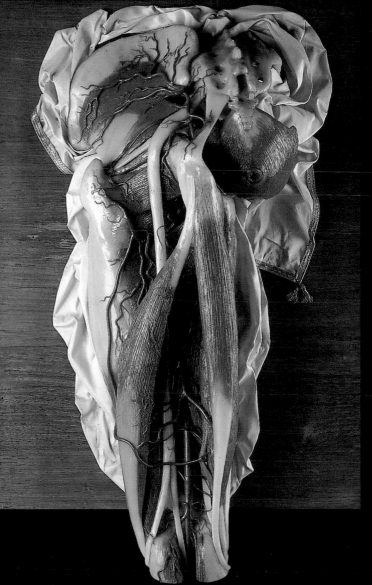

The thigh seen
from behind,
showing the
sciatic nerve and
popliteal artery

Ansicht des Ober-
schenkels von hin-
ten mit Darstellung
des Ischiasnerven
und der Knie-
kehlenarterie

Artères fessières
et poplitée, nerf
sciatique dans les
régions profondes
de la fesse, posté-
rieure de la cuisse,
et du genou

Pages · Seiten ·
Pages 114–115:

Detail from pages
116–117

Detail der Seiten
116–117

Détail des pages
116–117

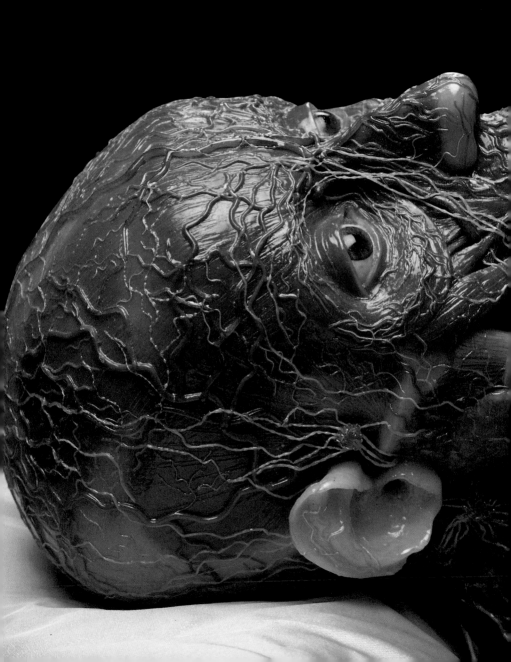

Systema lymphaticum
et splen

Lymphatic System
Lymphatisches System
Système lymphatique

Whole body specimen with the superficial
veins and lymphatic vessels

Ganzkörperpräparat mit Darstellung ober-
flächlicher Venen und Lymphgefäße

Préparation du corps entier représentant
les veines et les vaisseaux lymphatiques
superficiels

[XXVIII, 740]

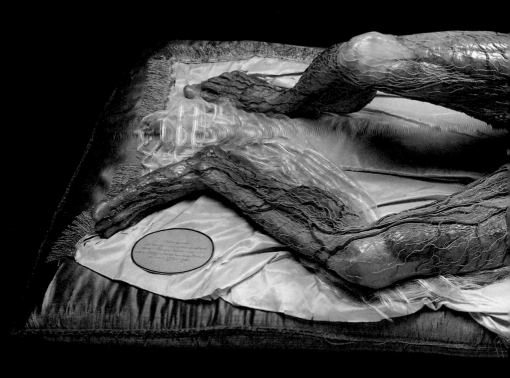

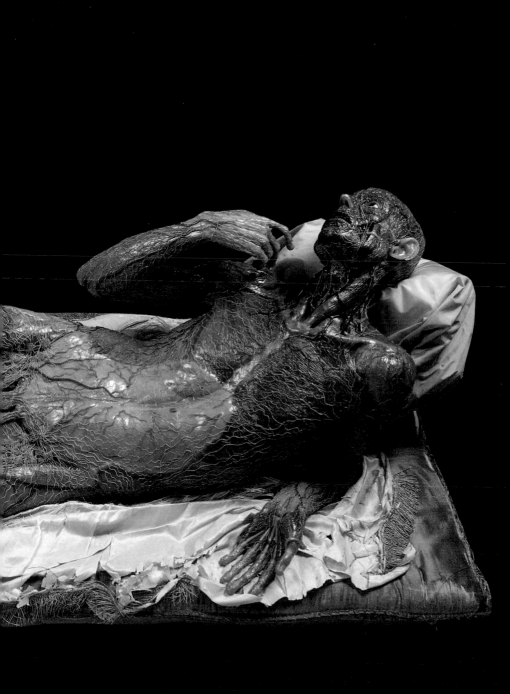

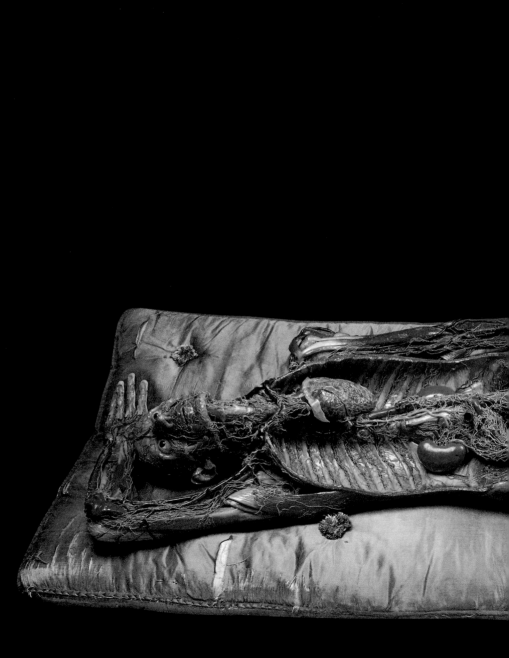

**Whole body specimen showing the
lymphatic vessels**

**Ganzkörperpräparat mit Darstellung des
Lymphgefäßsystems**

**Préparation du corps entier représentant
les grandes voies lymphatiques**

[XXVII, 646]

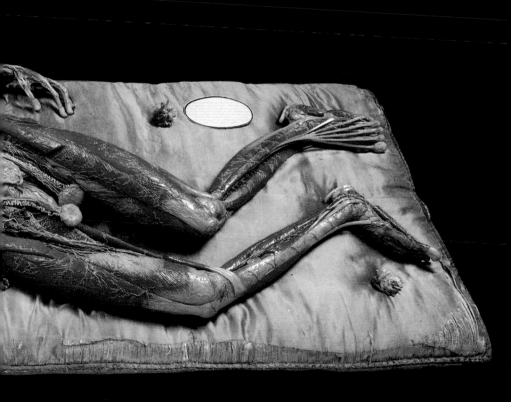

Different views of
lymph nodes with
efferent and affer-
ent lymphatic
vessels

Lymphknoten
in verschiedenen
Darstellungen mit
zu- und abführen-
den Lymphgefäßen

Nœuds lympha-
tiques (ganglions)
avec vaisseaux
lymphatiques affé-
rents et efférents

Lymphatic vessels
and nodes of the
head and neck.
The skull has been
laid open to reveal
the pia-arachnoid
and the brain. The
lymphatic vessels
of the pia-arach-
noid as displayed
in the specimen do
not exist.

Lymphgefäße und
Lymphknoten
im Bereich von
Gesicht, Hinter-
haupt und Hals.
Lymphgefäße in
der weichen Hirn-
haut, wie sie hier
im Präparat am
eröffneten Schädel
dargestellt sind,
existieren nicht.

Vaisseaux et
nœuds lympha-
tiques de la face,
de la nuque, et du
cou. Les lympha-
tiques représentés
au contact du cer-
veau n'existent
pas.

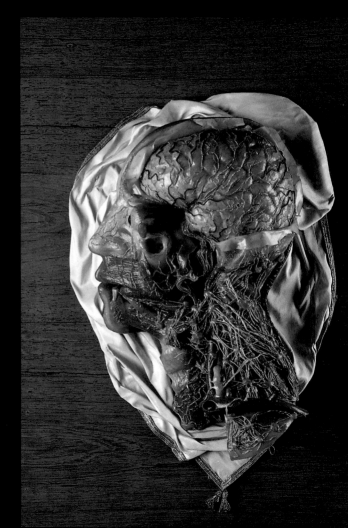

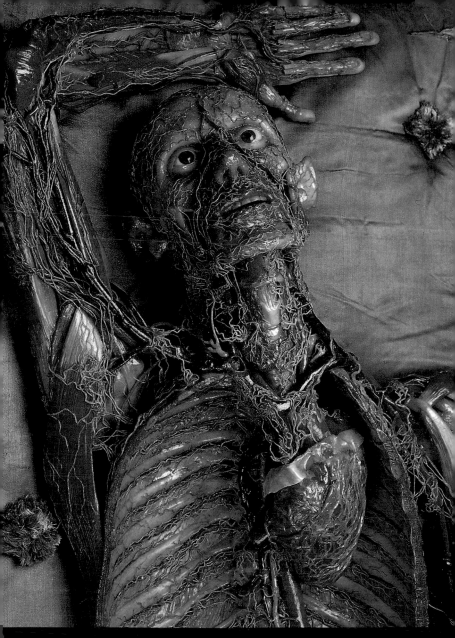

Lymphatic vessels
of the liver and on
the internal surface
of the breastbone.
The thoracic duct
can be discerned
as a pale cord.

Darstellung der
Lymphgefäße der
Leber und der
Innenfläche des
Brustbeins. Als
heller Strang ist
der Milchbrust-
gang erkennbar.

Vaisseaux lympha-
tiques du foie et de
la face profonde de
la paroi antérieure
du thorax

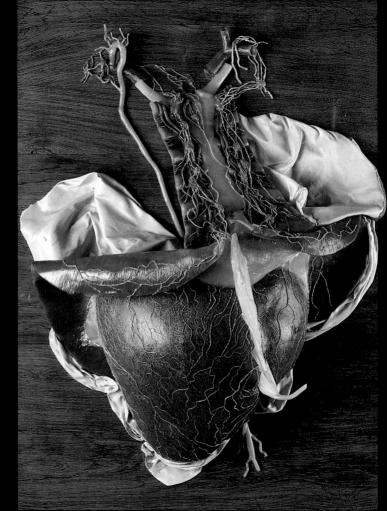

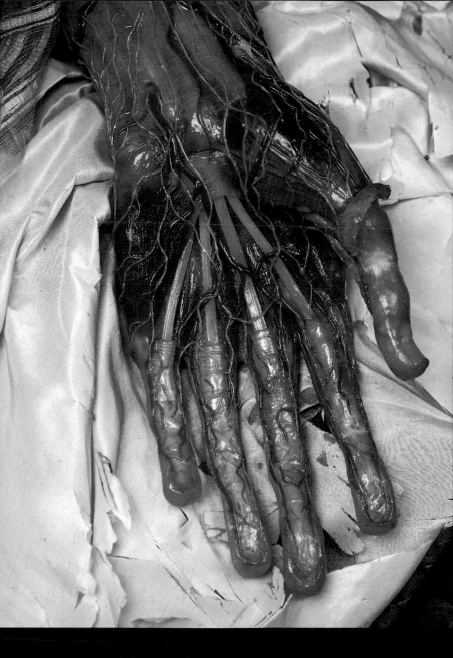

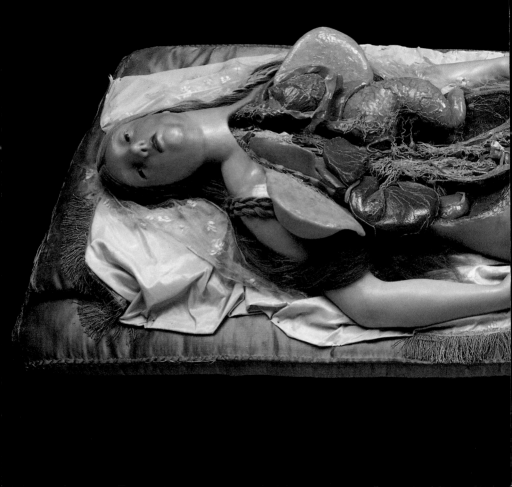

Préparation du corps entier représentant les
veines et les vaisseaux lymphatiques des
viscères du thorax et de l'abdomen

[XXIX, 745]

Lymph nodes and
lymphatic vessels
of the small intes-
tine

Darstellung der
Lymphknoten und
Lymphgefäße des
Dünndarmes

Vaisseaux et
nœuds lympha-
tiques de l'intestin
grêle et du mésen-
tère

Page · Seite ·
Page 129:

Whole body speci-
men showing the
lymphatic vessels
(detail)

Ganzkörperpräpa-
rat mit Darstellung
des Lymphgefäß-
systems (Detail)

Préparation du

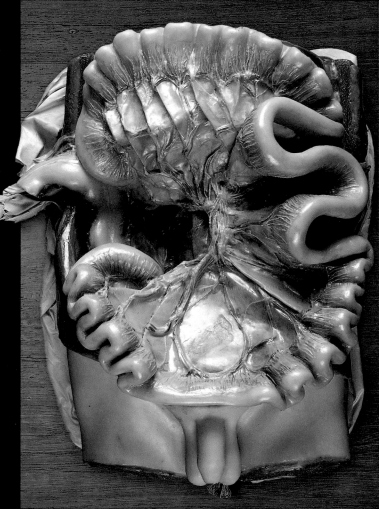

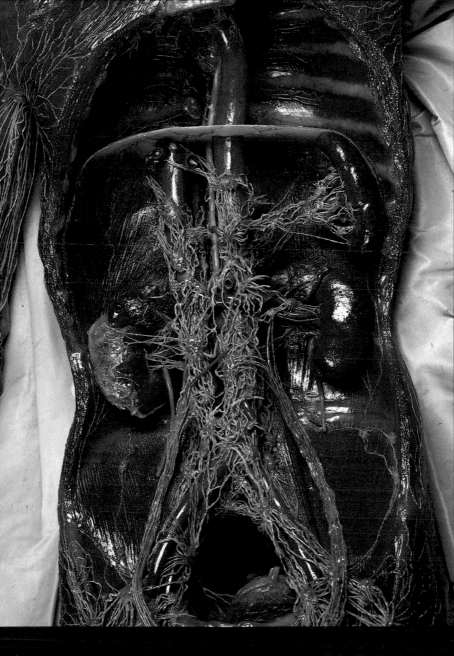

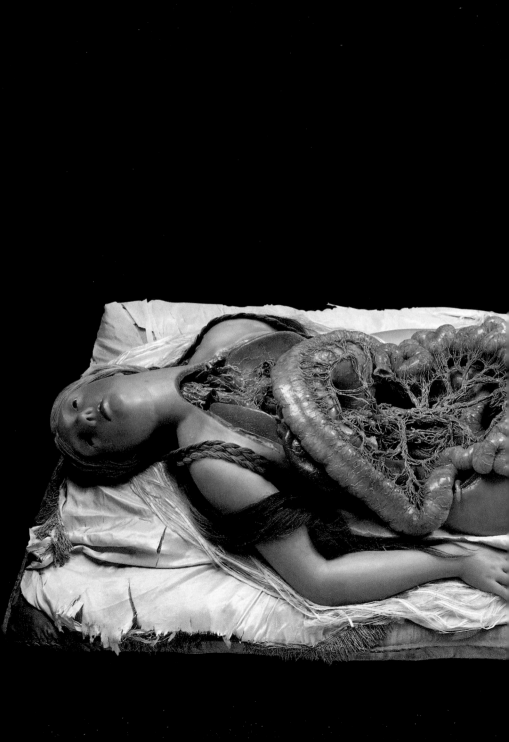

Vasa mesenterica

Whole body specimen showing the vessels
and lymph nodes within the abdominal
cavity

Ganzkörperpräparat mit Darstellung der
Gefäße und Lymphknoten der Bauchhöhle

Préparation du corps entier représentant
les veines et les vaisseaux et nœuds
lymphatiques des viscères de l'abdomen
et du thorax

[XXIX, 747]

Brain and Spinal Cord
Gehirn und Rückenmark
Encéphale

Specimen of a head. The calvaria has been removed and half of the brain can be taken out.

Präparat eines Kopfes. Das Schädeldach ist entfernt und eine Hirnhälfte herausnehmbar.

Tête ; ouverture de la voûte du crâne permettant d'enlever un hémisphère cérébral

Pages · Seiten · Pages 132–133:

Whole body specimen showing the lymphatic vessels (detail)

Ganzkörperpräparat mit Darstellung des Lymphgefäßsystems (Detail)

Préparation du corps entier représentant les veines et les vaisseaux lymphatiques (détail)

[XXVIII, 739]

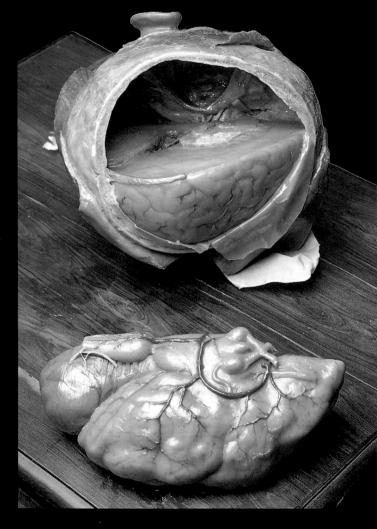

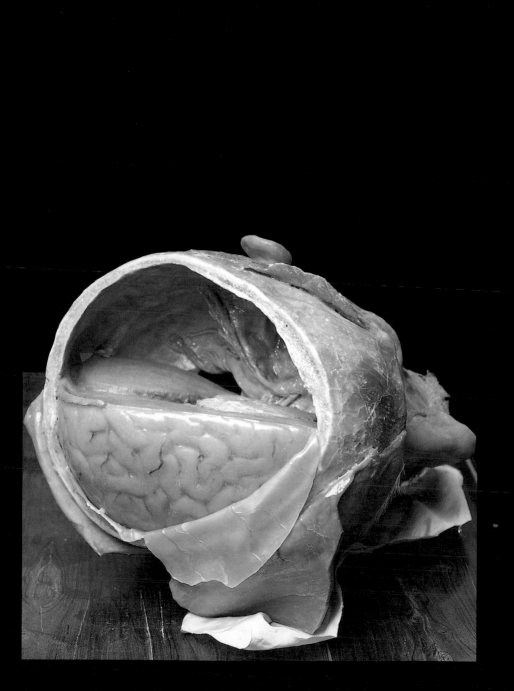

Detail from pages | Detail der Seiten | détail des pages 16–17

The calvaria of a
fetus seen from
above, showing the
anterior fontanelle
still open (left spec-
imen) and the dura
mater after removal
of the calvaria
(right specimen).
Below: the calvaria
seen from the
inside

Blick von oben auf
das Schädeldach
eines Föten mit
offener vorderer
Fontanelle (linkes
Präparat) und auf
die harte Hirnhaut
nach Enfernung
des Schädeldaches
(rechtes Präparat).
Unteres Präparat:
Innenansicht des
Schädeldaches

Voûte du crâne du
fœtus avec la fonta-
nelle antérieure
ouverte (en haut
à gauche) ; dure-
mère après abla-
tion de la voûte (en
haut à droite). En
bas : vue endocrâ-
nienne de la voûte

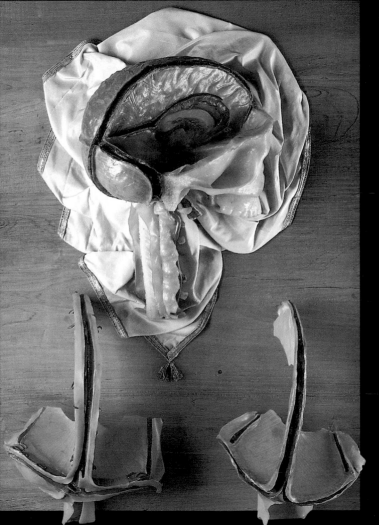

The venous
sinuses of the dura
mater

Darstellungen der
venösen Blutleiter
in der harten Hirn-
haut

Conduits veineux
limités par la
dure-mère (sinus
veineux)

Specimen showing the various arteries at the base of the brain

Darstellung verschiedener Arterien an der Hirnbasis

Artères de la base de l'encéphale

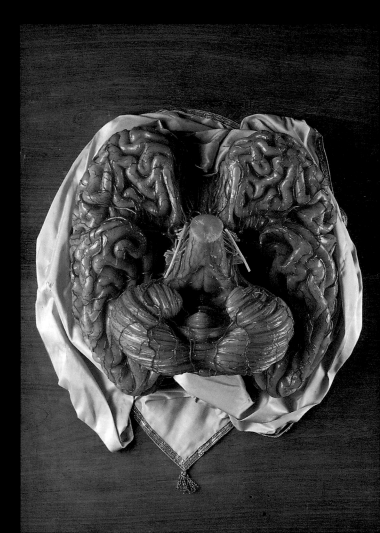

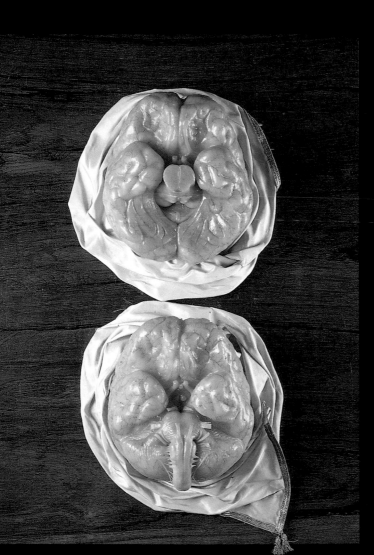

Base of the brain. In the upper specimen the main posterior lobes of the brain can be seen after the removal of the cerebellum.

Ansichten der Hirnbasis. Im oberen Präparat werden nach Entfernung des Kleinhirns die Hinterhauptslappen des Großhirns erkennbar.

Base de l'encéphale ; ablation du cervelet découvrant le lobe occipital (en haut)

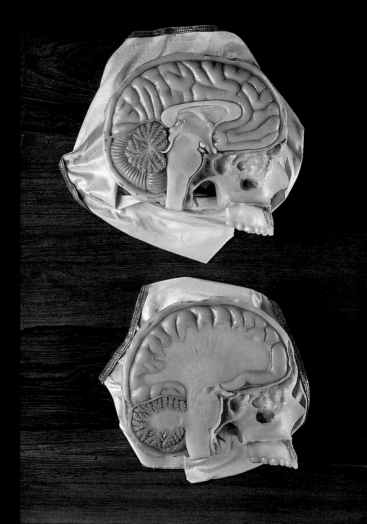

Median (above)
and paramedian
(below) sections
through the head

Medianschnitt
(oberes Präparat)
und Paramedian-
schnitt (unteres
Präparat) durch
den Kopf

Encéphale dans la
boîte crânienne :
sections médiane
(en haut) et para-
médiane (en bas)

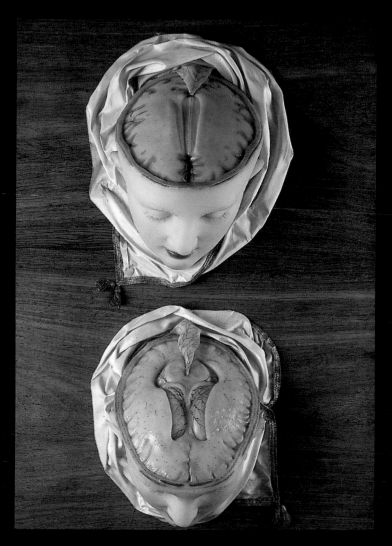

Horizontal sections through the skull a little above the corpus callosum (upper specimen) and a little below it (lower specimen). The lower section passes through the ventricles and the caudate nucleus.

Horizontalschnitte durch den Schädel etwas oberhalb des Balkens (oberes Präparat) und unterhalb des Balkens (unteres Präparat). Das untere Präparat zeigt Abschnitte der Hirnkammern und den Schweifkern.

Coupes horizontales du crâne et de l'encéphale : au dessus du corps calleux (en haut), et en dessous avec les ventricules cérébraux (en bas)

Thalamus, Nucleus caudatus, Ventriculus tertius, Ventriculi laterales

Horizontal sections at various levels through the skull. In the upper specimen one can see the caudate nucleus, and adjacent to and directly behind it, the thalamus.

Horizontalschnitte durch den Schädel auf verschiedenen Höhen, im oberen Präparat erkennt man den Schweifkern und nach hinten direkt angrenzend den Sehhügel.

Coupes horizontales du crâne et de l'encéphale : noyaux gris profonds

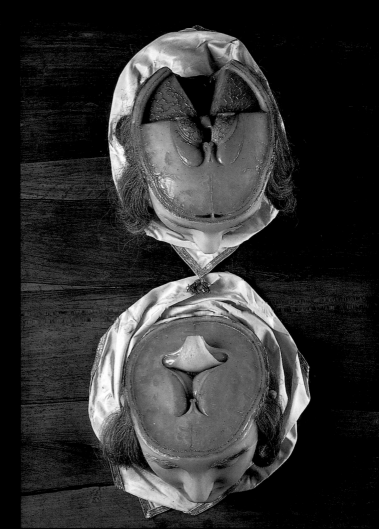

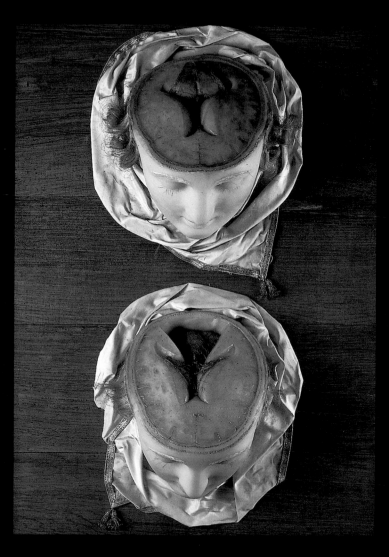

Horizontal sections through the skull. In the lower specimen a part of the brain near the back of the head has been removed to reveal the more deeply placed cerebellum.

Horizontalschnitte durch den Schädel. Im unteren Präparat ist nahe am Hinterkopf ein Teil des Großhirns entfernt, so daß das tiefer gelegene Kleinhirn sichtbar wird.

Coupes horizontales du crâne et de l'encéphale : ventricules, cervelet visible après ablation de la partie postérieure du cerveau

**Brain specimen
showing caudate
nucleus and thala-
mus (above) and
various structures
at the base of the
brain (below)**

**Ansicht auf Hirn-
präparate mit
Darstellung von
Schweifkern und
Thalamus (oberes
Präparat) und ver-
schiedener Struktu-
ren im Bereich der
Hirnbasis (unteres
Präparat)**

**Ventricules céré-
braux et noyaux
gris profonds dis-
séqués (en haut) ;
base de l'encéphale
(en bas)**

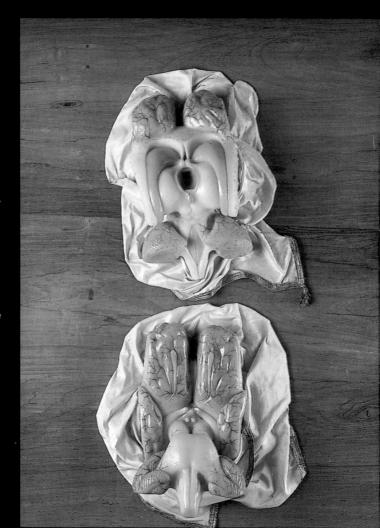

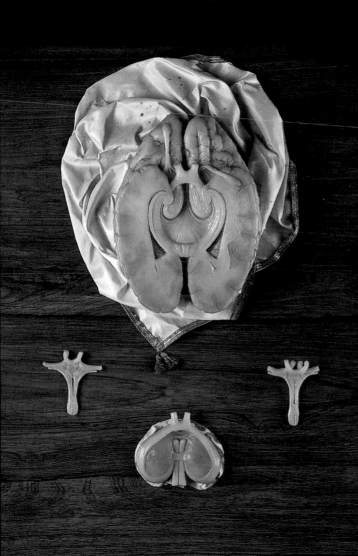

Specimens show-
ing the connections
(nerve fibers) of the
hippocampus

Präparate zur
Darstellung der
Nervenfaser-
verbindungen des
Hippocampus

Connexions
nerveuses de
l'hippocampe

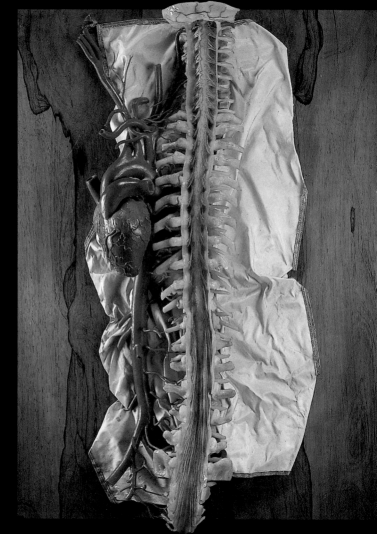

The vertebral canal
has been laid open
from behind to
show the spinal
cord, the spinal
nerve roots and the
supplying blood
vessels

Einblick in den
eröffneten Wirbel-
kanal von hinten
mit Rückenmark,
austretenden Ner-
venwurzeln sowie
versorgenden Blut-
gefäßen

Artères de la mœlle
épinière et des
nerfs spinaux
(rachidiens) ; canal
vertébral ouvert vu
de l'arrière

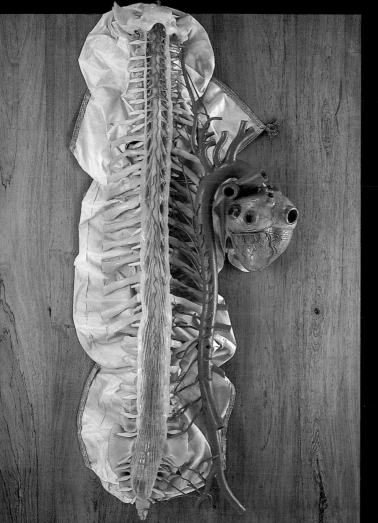

The vertebral canal
has been laid open
from in front to
show the spinal
cord, emerging
spinal nerve roots
and blood vessels

Einblick in den
eröffneten Wirbel-
kanal von vorn mit
Rückenmark, aus-
tretenden Nerven-
wurzeln sowie Blut-
gefäßen

Artères de la mœlle
épinière et des
nerfs spinaux ;
canal vertébral
ouvert vu de l'avant

Nervi craniales et Organa sensoria

Cranial Nerves and Sense Organs
Hirnnerven und Sinnesorgane
Nerfs crâniens et organes de sens

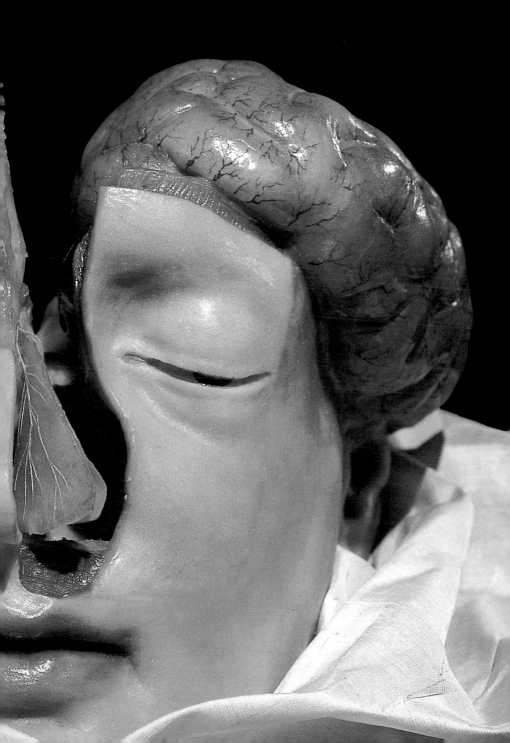

One of the sensory
nerves of the tongue

Darstellung eines
sensiblen Nerven
für die Zunge

Nerf trijumeau :
branches pour la
sensibilité de la
langue

*Pages · Seiten ·
Pages 148–149:*

Frontal view of dis-
play showing the
first subdivision
of the trigeminal
nerve. A part of the
frontalis muscle
can be seen on the
left, across which
single branches
of the trigeminal
nerve are running.

Frontansicht eines
Präparats mit dem
ersten Ast des Ner-
vus trigeminus.
Links ist ein Teil
des Stirnmuskels
zu sehen, auf dem
einzelne Trigemi-
nusäste verlaufen.

Vue frontale de la
préparation ana-
tomique du nerf
trijumeau : branche
supérieure ramifiée
à la surface du
muscle frontal

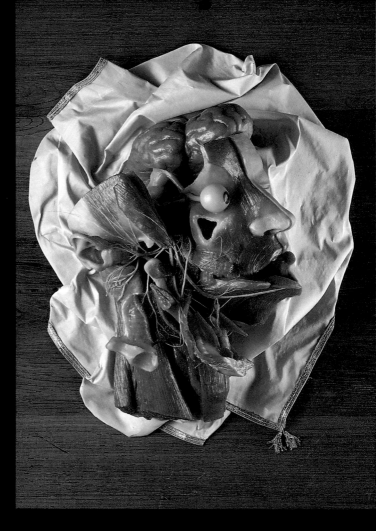

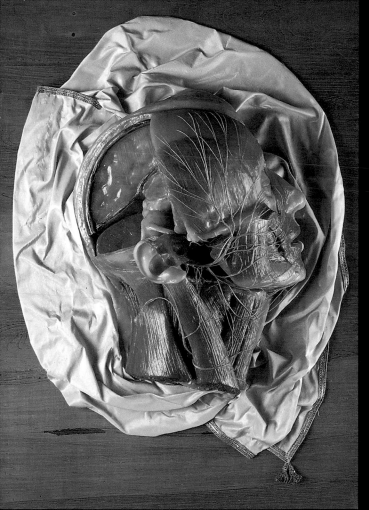

Display showing
the facial nerve,
which supplies the
muscles of facial
expression

Darstellung des
Nervus facialis, der
die mimische Mus-
kulatur innerviert

Nerf facial :
branches pour les
muscles peauciers
de la mimique

Specimen of
the ear with the
external auditory
meatus, eardrum,
middle ear and
Eustachian tube

Präparat einer
Ohrmuschel mit
äußerem Gehör-
gang, Trommelfell,
Mittelohr sowie der
Ohrtrompete

Pavillon de l'oreille,
conduit auditif
externe, tympan,
caisse du tympan,
et trompe auditive
(d'Eustache)

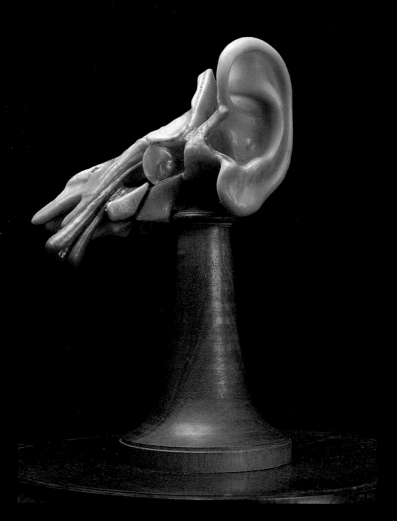

Display showing
the organs of hear-
ing and balance,
and the motor
nerve of the face
passing through
the petrous tem-
poral bone

Darstellung von
Gehör-, Gleich-
gewichts- und
motorischem
Gesichtsnerv im
Felsenbein

Nerf de l'audition
et de l'équilibra-
tion, nerf de la
mimique (facial)
dans l'os temporal

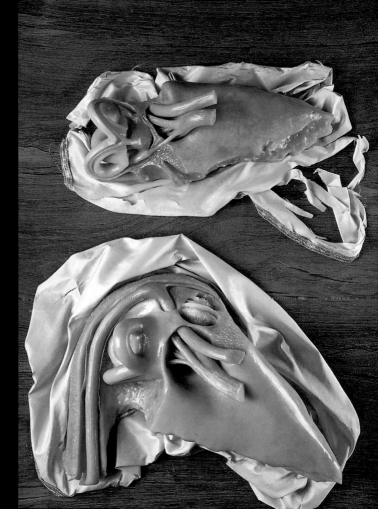

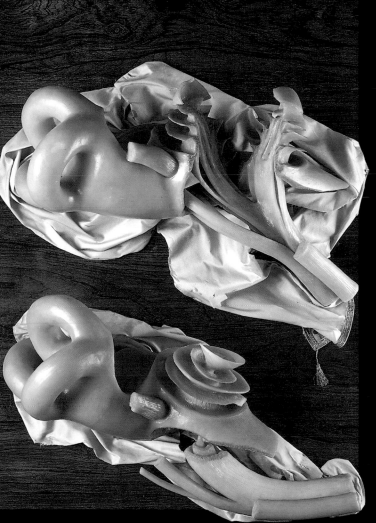

Greatly enlarged
specimen of the
inner ear showing
the semicircular
canals and the con-
volutions of the
cochlea

Darstellung des
stark vergrößerten
Innenohres mit
Bogengängen und
Windungen der
Schnecke

Oreilles internes
fortement agran-
dies : canaux semi-
circulaires, tours de
spire de la cochlée

Specimen showing
the left vagus nerve

Darstellung des lin-
ken Vagusnerven

Nerf vague gauche

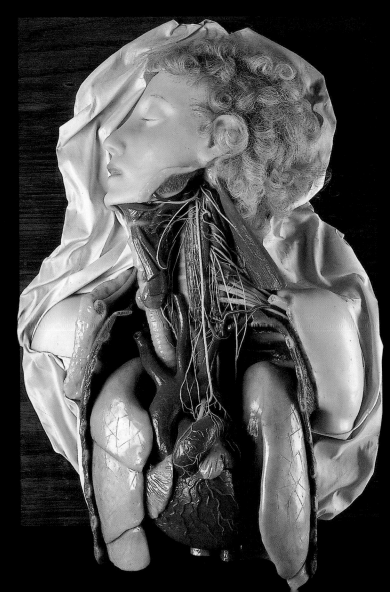

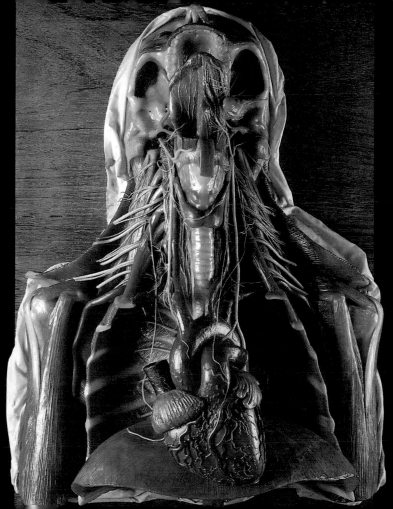

Specimen in which the head has been powerfully hyperextended backwards. The lower jaw has been removed. The neurovascular bundle of the neck including the vagus nerve is displayed.

Präparat mit stark nach hinten überstrecktem Kopf. Der Unterkiefer ist entfernt. Dargestellt ist die Gefäßnervenstraße des Halses mit dem Vagusnerv.

Nerf vague, nerfs et artères du cou (tête en forte extension, mandibule enlevée)

Variations in the
origin and course
of the eleventh
cranial nerve

Varianten im
Ursprung und
Verlauf des elften
Hirnnerven

Nerf accessoire
(spinal), onzième
nerf cranien : varia-
tions de l'origine
et du trajet

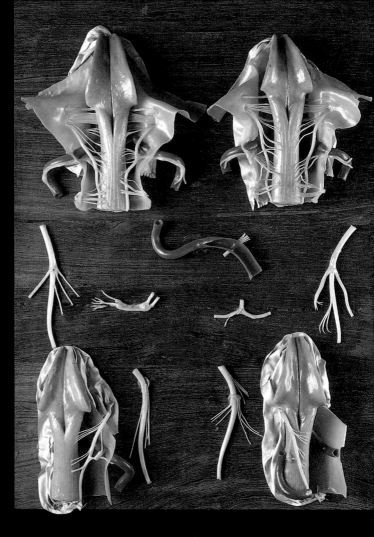

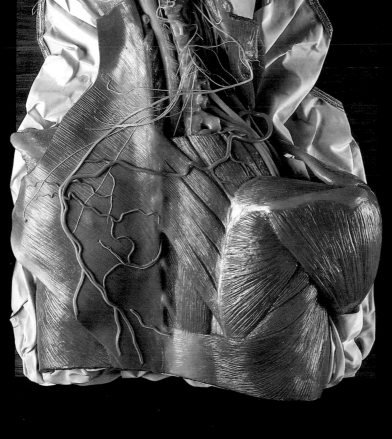

Display showing
the course of the
eleventh cranial
nerve to the trapez-
ius muscle

Darstellung des
Verlaufes des elften
Hirnnerven zum
Trapezmuskel

Nerf accessoire :
innervation du
muscle trapèze

Median section of
the scull. One can
discern the bony
roof of the oral
cavity and the
papillae of the
tongue.

In der Mitte durch-
trennter Schädel.
Man erkennt das
knöcherne Dach
der Mundhöhle
und die Papillen
der Zunge.

Organes du goût :
papilles de la
langue (cavité
buccale vue après
section médiane
du crâne et écarte-
ment des deux
moitiés)

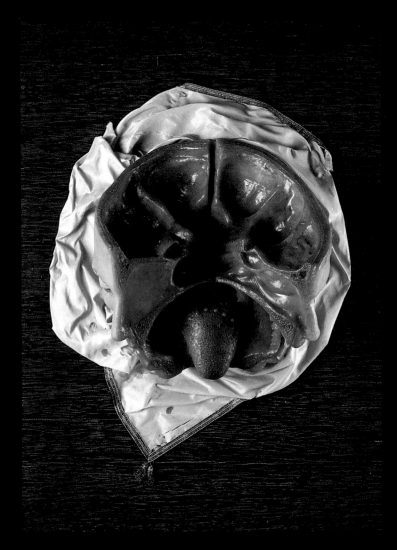

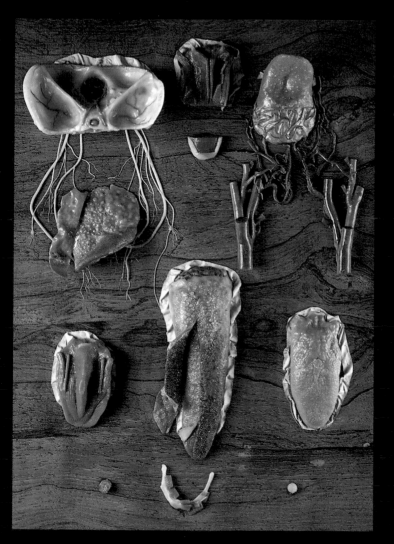

**Nerves and vessels
of the tongue**

**Nerven und Gefäße
der Zunge**

**Nerfs et vaisseaux
de la langue**

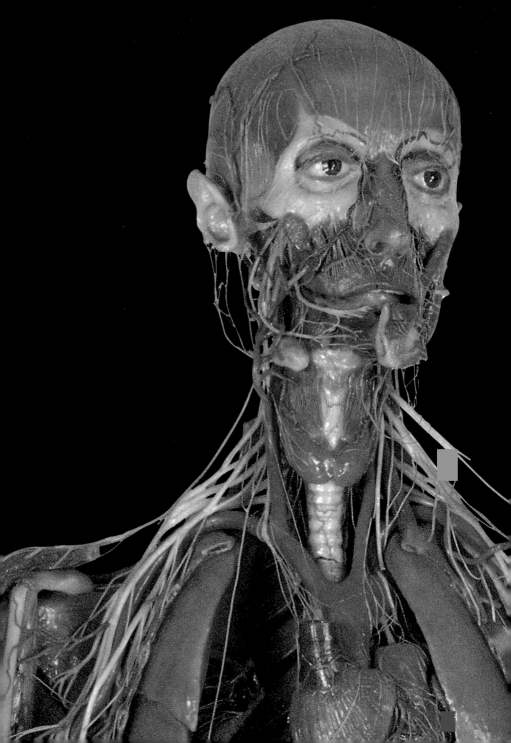

Systema nervosum peripheriale et autonomicum

Spinal Nerves and Autonomic Nervous System
Spinalnerven und autonomes Nervensystem
Nerfs spinaux et système nerveux autonome

Whole body speci-
men with muscles
and nerves from
behind

Ganzkörperpräpa-
rat zur Darstellung
der Muskulatur
und Nervenläufe
an der Körperrück-
seite

Préparation du
corps entier repré-
sentant les nerfs
des régions posté-
rieures

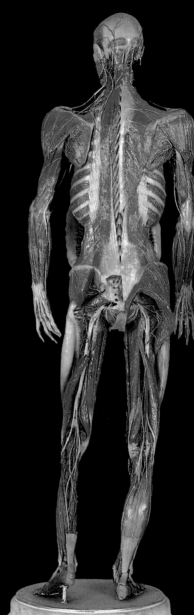

Pages · Seiten ·
Pages 162–163:

Detail from page
165

Detail von Seite 165

Détail de la page
165

Whole body specimen with muscles and nerves from front

Ganzkörperpräparat zur Darstellung der Muskulatur und Nervenläufe an der Körpervorderseite

Préparation du corps entier représentant les nerfs des régions antérieures

The nerves in a
deeper layer of the
neck. Above the
thoracic cage one
can see parts of the
nerve plexus of the
upper limb.

Nerven des Halses
in einer tiefen
Schicht. Oberhalb
des Brustkorbs er-
kennt man Anteile
des Armnerven-
geflechtes.

Nerfs des régions
profondes du cou,
plexus nerveux
brachial au dessus
de la première côte,
nerfs intercostaux

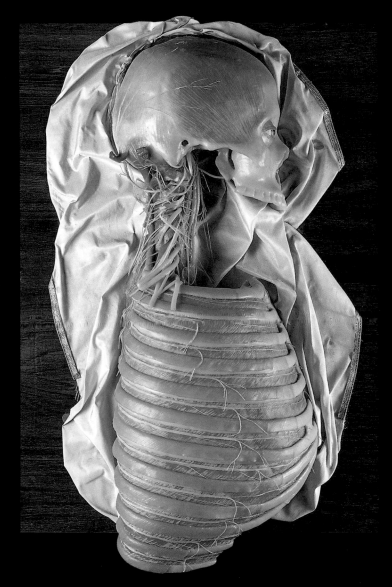

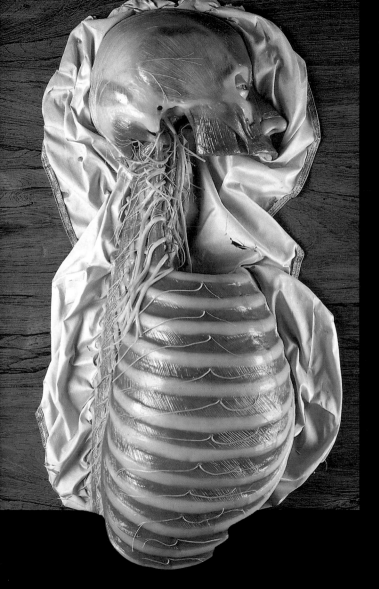

Deeper layer show-
ing cervical plexus
and plexus of the
upper limb

Hals- und Armner-
vengeflecht in einer
tiefen Schicht

Plexus nerveux cer-
vical et brachial,
rameaux des nerfs
intercostaux

The nerves of the
upper limb and
side of the chest
wall

Darstellung der
Nerven der seit-
lichen Brustwand
sowie des Armes

Nerfs du membre
supérieur vus du
côté droit

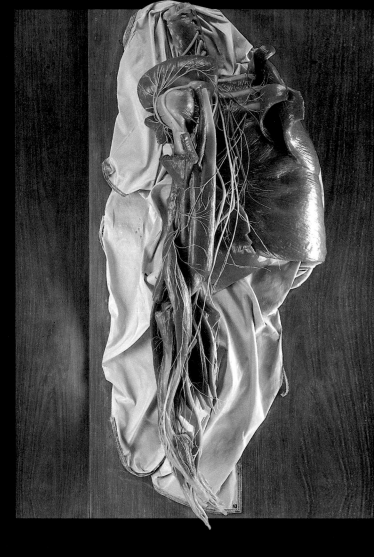

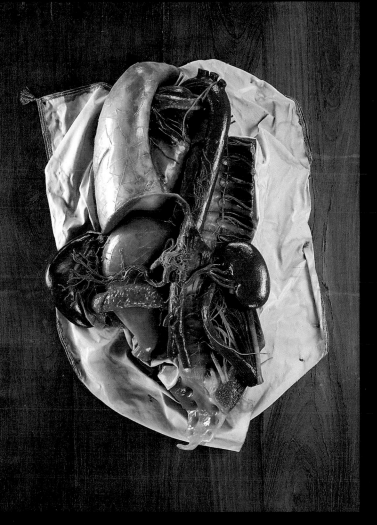

Specimen showing the viscera with the arteries and their associated autonomic nerve fiber plexuses

Eingeweidepräparat mit Arterien und begleitenden vegetativen Nervenfasergeflechten

Système nerveux végétatif autour des artères se destinant aux viscères de l'abdomen

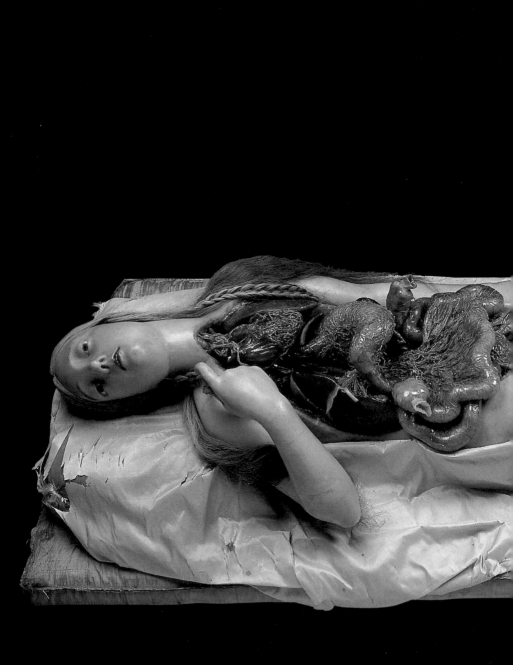

Systema digestorium et respiratorium

Viscera
Eingeweide
Appareil digestif, appareil respiratoire

Display showing
the arterial blood
supply of the stom-
ach, liver and gall-
bladder

Darstellung der
arteriellen Versor-
gung von Magen,
Leber und Gallen-
blase

Artères de l'esto-
mac, du foie, et de
la vésicule biliaire

Pages · Seiten ·
Pages 170–171:

Whole body speci-
men showing the
lymphatic vessels
in the thoracic and
abdominal cavities

Ganzkörperpräpa-
rat mit Darstellung
der Lymphgefäße
in Brust- und
Bauchraum

Préparation du
corps entier repré-
sentant les vais-
seaux lympha-
tiques des cavités
thoraciques et
abdominale

[XXIX, 746]

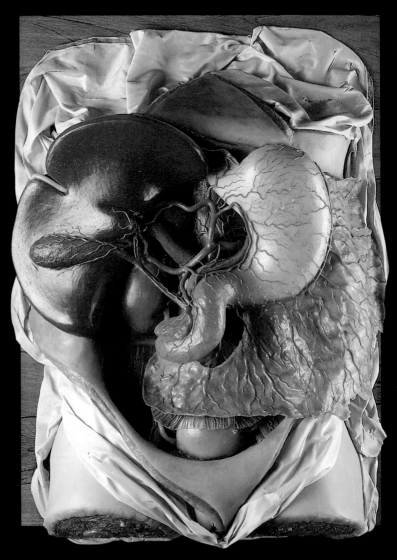

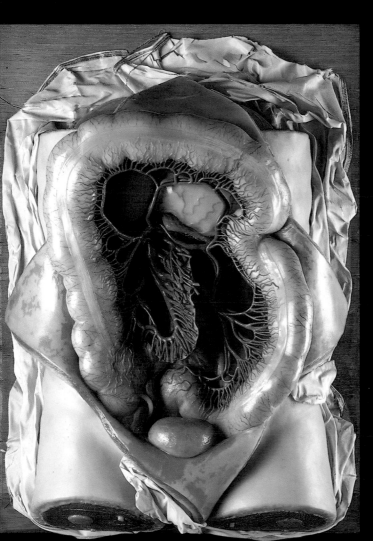

Display showing
the arterial blood
supply of the large
intestine

Darstellung der
arteriellen Versor-
gung des Dick-
darmes

Artères du gros
intestin

*Page · Seite ·
Page 175:*

Male torso with
the thoracic and
abdominal cavities
laid open

Männlicher Torso
mit Einblick in die
eröffnete Brust-
und Bauchhöhle

Viscères du thorax,

Systema urogenitale et genitale

Urinary and Reproductive System

Harn- und Geschlechtsorgane

Appareil urinaire, appareil génital

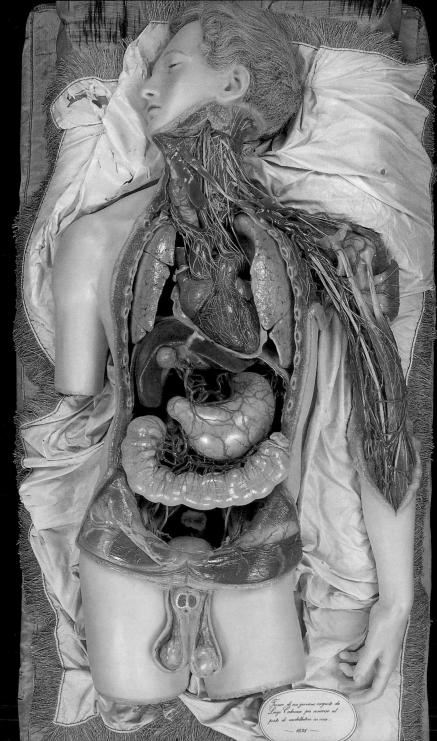

Torso di un giovane eseguito da Luigi Calamai per concorso al posto di modellatore in cera.
1835

View of the poster-
ior abdominal wall
after removal of the
abdominal viscera.
Kidneys, upper uri-
nary tract, urinary
bladder, aorta and
inferior vena carva

Blick auf die
hintere Bauchwand
nach Entfernung
der Bauchorgane.
Darstellung der
Nieren, der Harn-
leiter, der Blase
sowie der Bauch-
schlagader und der
unteren Hohlvene

Reins, uretères,
vessie, aorte abdo-
minale et veine
cave inférieure
contre la paroi
postérieure de
l'abdomen après
résection des
autres viscères

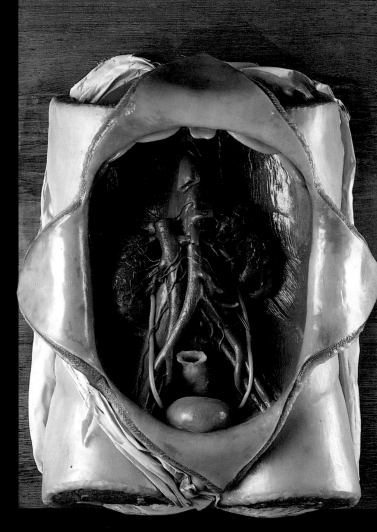

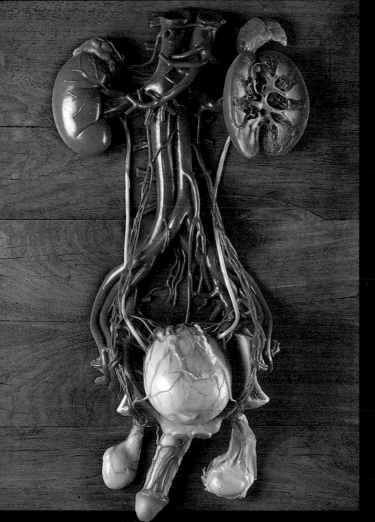

View of the male
pelvic floor from
below

Blick von unten auf
ein Präparat des
männlichen
Beckenbodens

Plancher du bassin
masculin vu du
dessous

Specimens of the
female breast

Präparate der
weiblichen Brust

Seins, glande
mammaire

Female external
genital organs

Darstellung der
äußeren weiblichen
Geschlechtsorgane

Organes génitaux
externes féminins
(position gynécolo-
gique)

*Pages · Seiten ·
Pages 180–181:*

Whole body
specimen seen
from below
(cf. pp. 170–171)

Ganzkörperprä-
parat in Untersicht

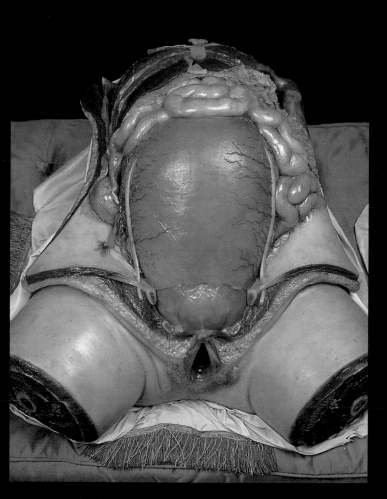

Lower part of the
belly of a pregnant
woman; abdominal
cavity laid open

Präparat eines
Unterleibes einer
Schwangeren mit
eröffneter Bauch-
höhle

Utérus à la fin de
la grossesse après
ouverture de la
paroi abdominale

mutter einer
Schwangeren mit
sich öffnendem
Muttermund

Fœtus jumeaux
dans l'utérus
ouvert, béance
du col utérin

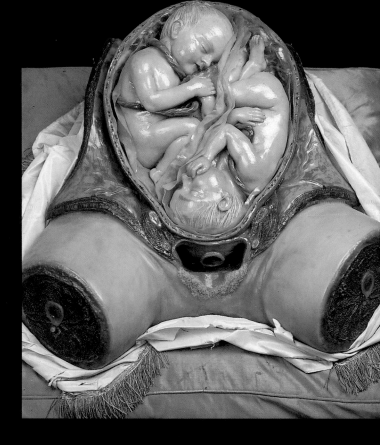

**Specimen showing
a fetus within the
amniotic sac**

**Darstellung eines
Fötus in der Frucht-
blase**

**Fœtus dans le sac
et le liquide amnio-
tique dans l'utérus
ouvert**

Fetus with abdom-
inal cavity laid
open to display the
umbilical arteries
and vein

Präparat eines
Föten mit eröffne-
tem Bauchraum
zur Darstellung der
Nabelarterien und
der Nabelvene

Fœtus : artères et
veines ombilicales

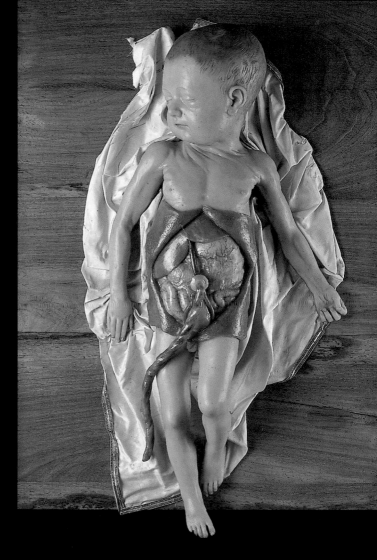

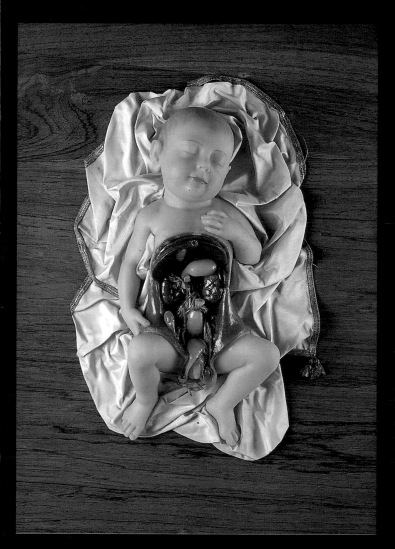

Fetus with abdominal cavity laid open and abdominal organs removed to display the urogenital system. The left testis has descended into the scrotum, the right testis is in the abdominal cavity.

Präparat eines Föten mit eröffnetem Bauchraum. Zur Darstellung der Urogenitalorgane sind die Bauchorgane entfernt. Der linke Hoden ist in den Hodensack abgestiegen, der rechte Hoden befindet sich im Bauchraum.

Fœtus : appareils urinaire et génital ; testicule gauche descendu dans les bourses, testicule droit encore dans la cavité abdominale

"Buy them all and add some pleasure to your life."